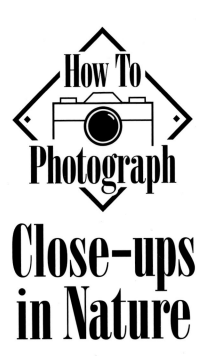

How To
Photograph
Close-ups
in Nature

How To

Photograph

Close-ups in Nature

Nancy Rotenberg
and Michael Lustbader

STACKPOLE
BOOKS

Published by
STACKPOLE BOOKS
5067 Ritter Road
Mechanicsburg, PA 17055
www.stackpolebooks.com

Printed in China

First edition

10 9 8 7 6 5 4 3 2 1

Cover design by Wendy Reynolds

Library of Congress Cataloging-in-Publication Data

Rotenberg Nancy.
 How to photograph close-ups in nature / Nancy Rotenberg
 and Michael Lustbader.
 p. cm. — (How to photograph)
 Includes bibliographical references (p.).
 ISBN 0-8117-2457-3
 1. Nature photography—Handbooks, manuals, etc.
2. Photography, Close-up—Handbooks, manuals, etc.
I. Lustbader, Michael. II. Title. III. Series.
TR721.R68 1999
778.9'3—dc21 99-11916
 CIP

C O N T E N T S

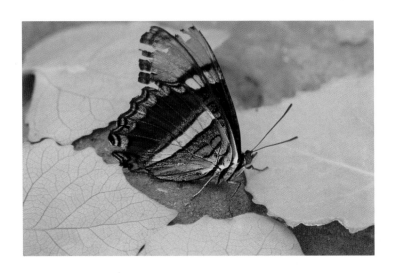

PREFACE

One afternoon in Zion National Park, I was strolling along a path that in the rainy season would have been a meandering tributary, swollen with water. Now, in the dry conditions of fall, this arroyo offered a quiet place to search for potential photographic subjects. As I walked, I began to notice the designs on sandstone walls, small footprints going this way and that, the amazing blueness of juniper berries, the deep crimson of a sawtooth maple leaf. The songs of a canyon wren and the pungent odor of sage enveloped me, and I began to feel a part of this incredible landscape.

After a while, I found myself seeing more and looking deeper. Some fallen cottonwood leaves drew me in for a closer inspection. As I marveled at their intricate design, a movement on one of the leaves caught my attention. Perched on a curl of the leaf, an almost totally camouflaged swallowtail butterfly made itself known to me. Strangely, it didn't seem to be in a hurry to flit anywhere. Thrilled by the chance to photograph it, I quickly set up my tripod and lay down on the sand to get an eye-level view of this wonderful creature.

After exposing a few images, I crawled a little closer. As the wings became more visible, I began to see many tatters and wounds. On a whim, I offered my hand, and the butterfly stepped onto it.

I'm not sure how long we shared that moment in time, but at some point, he flew away. I sat for a long while after his departure, watching the cottonwood leaves dance where the butterfly had once stood. All else was quiet and still.

I did photograph the butterfly that day, but what was most important was not the image on the light table. What provides my photographic inspiration and passion and remains long after the fleeting, transitory moments are memories such as the feeling of a butterfly in my hand, and lying down amid the smells and sounds of an arroyo.

—*Nancy Rotenberg*

Left: Butterfly on cottonwood leaves. *I photographed this butterfly as it was departing from our encounter. It was not the image that impressed me most, but the emotions of that day in an arroyo.* N. R.

ACKNOWLEDGMENTS

There are those whose support and love never seem to dwindle . . .

To Marci and Jamie, who with their own special visions patiently critiqued those first images, and who never tire of receiving publications of their mom's work. To my mother, Adele, who gives me love and only a little grief for being on the road too much. To my father, Bill, whose memory writes and photographs with me in my heart.

To Michael, whose friendship captured me with his generosity of sharing and hunger for knowledge. As my partner, he always has extra batteries, know-how for repairs, updates on equipment, an eye for finding frogs, patience for "wonderful connectedness," and the childlike innocence and love of nature's magic.

To my traveling buddies Bucky (a.k.a. Deborah), Ellen, Linda, and Marian; thanks for your friendship, for putting up with my frantic U-turns, and for sharing in the joy of "being lost."

We never arrive at a place without help along the journey. From the beginning, there were many photographers who inspired and encouraged me. I would particularly like to acknowledge the educational skills of John Shaw and the inner vision of Brent McCullough. John's lessons on exposure and close-up photography set the groundwork for establishing necessary photographic technique. Brent, through his workshops and friendship, shared inexhaustible enthusiasm and offered many opportunities for developing awareness.

I am grateful for the spirituality of Minor White, who understood the gifts that a day could bring, and for the passion of Freeman Patterson, whose words and emotion bring such joy to the creation of images. Thanks also to Dewitt Jones and Jim Brandenburg for their personal inspirations in the importance of following your heart.

And to our students and fellow photographers who believed "it could happen." I wish for them the special gifts a day can bring.

N. S. R.

Writing this book would not have been possible without the faith and encouragement of Mark Allison and Jon Rounds of Stackpole Books, who first saw our images and then believed in us.

M. L. L.

INTRODUCTION

Many of us view the world from a distance or think that great photographs are made possible only by traveling to exotic destinations. With close-up photography, however, potential images are found just about everywhere. There are microcosms in your backyard, in the park down the street, or in the woods. We love to travel and relish the thought of an adventure, but many of the images we love the best are those we discovered in our garden and farm fields. Although we do love to photograph grand vistas and larger scenics, close-up images provide intimate ways of expressing ourselves.

Through visual curiosity and by investigating the world close up, we discover beauty in the commonplace and wonder in the underlying harmony and connectedness of nature. We are treated to worlds within worlds in which amazing discoveries are possible. Dewdrops clinging to a blade of grass, rainbows on a butterfly wing, intricate patterns of a leaf, spring buds in the garden, and ice formations on a window all become subjects for the macro photographer.

Looking at transparencies on the light table can be a frustrating experience. We've spent hours agonizing over slides that don't seem to capture what we experienced in the field. The film can be well exposed, well composed, and generally photographically correct, but still the images may somehow be lacking.

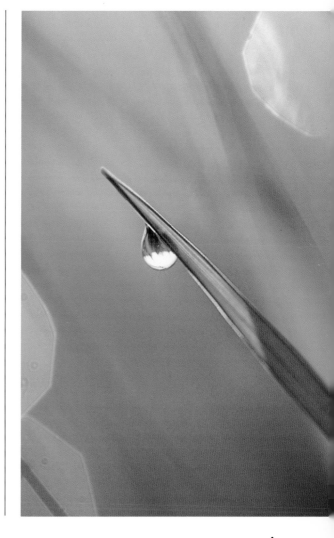

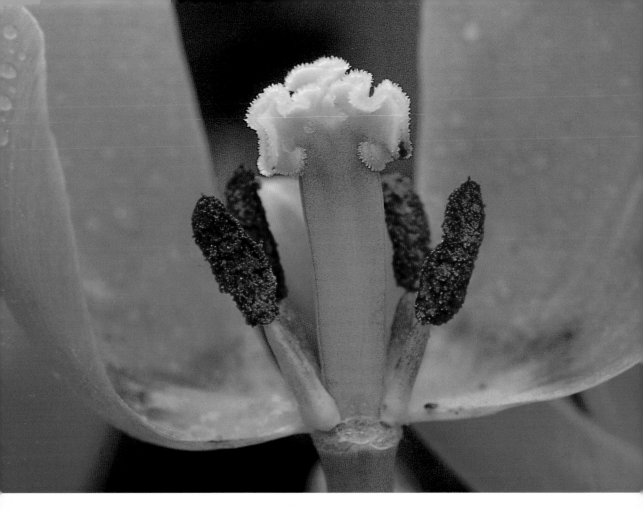

Above: Tulip close-up. *Spring is a wondrous season, and I wanted to capture its feeling of growth and rebirth. The tulips in our garden had peaked, and although images of the flower beds filled with tulips were interesting, I was more moved by this personal and intimate photograph of the stamens and pistil of one tulip. A 200mm macro lens compressed the background and foreground distances. To further enhance the brightness at the top of the stamen and to bring out the warm colors of the tulip, a gold reflector was positioned to reflect the sun's glow onto the subject.* N. R.

Previous page: Raindrop on grass. *Many photographers feel that they have to travel to exotic destinations to find potential subjects. One of the benefits of close-up photography is that there are potential subjects everywhere. Grass is often dripping with rain or dew first thing in the morning. It's really fun to crawl into it and explore the variety of images. To get this one blade of grass sharp, I had to lie flat on the ground and shoot through other blades. The specular highlights caused by other drops of water act as a frame for the subject. When photographing drops of water, you may have to try a few exposures before you get the timing just right. Some patience, a fast shutter speed, a 105mm macro lens, and a 5T close-up lens captured the exact moment when this drop of rain was ready to fall. The overcast sky provided even light, and I used an f-stop of 5.6 to place the background out of focus, thus bringing the drop and blade of grass into prominence.* N. R.

Successful photography requires the grasp of technical knowledge combined with the ability to capture the poetic. Science is essential to transfer images onto film, but it is poetry that will carry that image to a higher, more emotional, and thus more successful level.

While in the field one snowy day, a fellow photographer was deep in concentration, intent on capturing her image. She adjusted her tripod and tilted the camera a little. She checked her exposure, and then opened up one stop, accommodating for the white snow. An investigation and sweep around the frame revealed a tree branch protruding into the bottom right corner. She changed her composition. Taking time to make sure all was how she wanted it, she paused and gave a sweet sigh. To us, this represents the perfect equation: the practice of the technical with an infusion of the emotional.

Praying mantis on sunflower. *One of my favorite pastimes is having morning coffee while roaming through our garden. Gardens are constantly changing, and it is a joy to discover the small worlds that are created when we plant them. This particular morning, a female praying mantis (distinguished by her swollen stomach) was hanging upside down on a sunflower. I watched for a while, and then, realizing that she was unconcerned with my presence, put my coffee down to get my camera. Although mantids are pretty tolerant subjects, I didn't want to frighten her or interfere with her activities. To give her some space and distance from my lens, I chose a 200mm macro lens. Keeping the camera back parallel with the plane of the mantis maximized depth of field.* N. R.

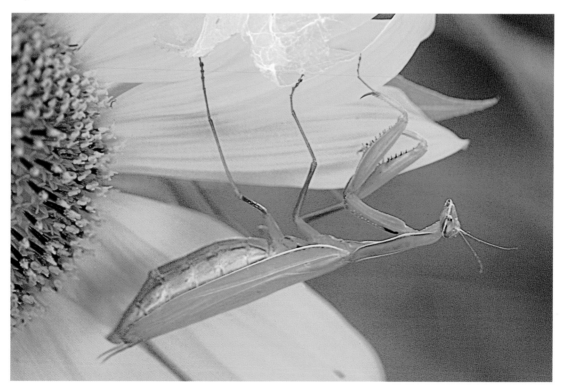

We urge you not to stop growing once you grasp the technical aspects of photography. The equation is not complete without the inclusion of the passion, vision, and awareness that you as interpreter can give to your images.

In this book we discuss equipment and technical concepts such as magnification, exposure, and lighting, but we also examine the creative process, how to improve seeing, and the incorporation of esthetics and meaning into your images.

Exposure

Photography might be defined as the process of drawing with light. Film must be exposed to light in order to create an image. If, however, the film is struck by either too much or too little light, the final image will be either lighter or darker than the original subject. If you simply follow your camera meter's recommendations, you'll notice soon enough that though some images look fine, others are too light or too dark.

Measuring and Controlling Light

The amount of light that strikes the film is determined by the size of the opening through which the light passes—the lens aperture—and the amount of time the shutter remains open, known as the shutter speed. The numbers on the lens barrel, called f-stops, represent the size of the opening, or aperture, in the lens diaphragm through which the light must pass. The larger numbers represent smaller openings, and the smaller numbers represent larger openings. Each subsequent f-stop lets in half as much light as the one before it and twice as much light as the one following. Apertures may be set in between the whole-number settings.

In addition to allowing the passage of more light, aperture diameter also influences depth of field, which refers to the area within an image in which everything is sharp. The smaller the aperture, the greater the depth of field, and vice versa. Changing from a larger f-stop to a smaller one is referred to as "stopping down," and going from a smaller f-stop to a larger one is called "opening up."

Shutter Speeds

Within the camera, a shutter mechanism in front of the film prevents light from striking the film until you press the button to make the exposure. Shutter speed settings control the amount of time this curtain remains open to allow the light to pass. Shutter speeds are measured in full seconds and fractions of seconds, and as with f-stops, each shutter speed allows twice as much light as the one after it and half as much as the one before it.

Changes in stops of light, whether determined by shutter speeds or apertures, indicate a doubling or halving of the amount of light striking the film. Shutter speeds can generally be set only at full stops, although most electronic cameras have intermediate stops that allow you to set in between shutter speeds and fine-tune the exposure. If you are shooting in an automatic or program mode, most of these cameras will set shutter speeds to intermediate settings.

Shutter speeds also determine the camera's ability to freeze action. The faster the shutter speed, the greater the motion-stopping ability. At 1/30 of a second, a butter-

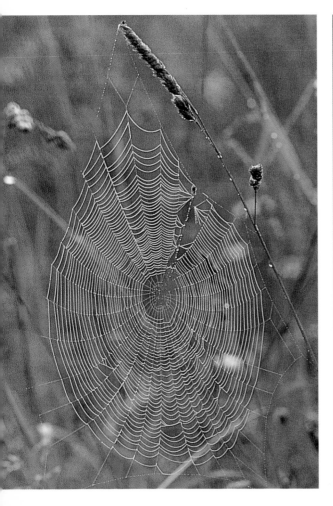 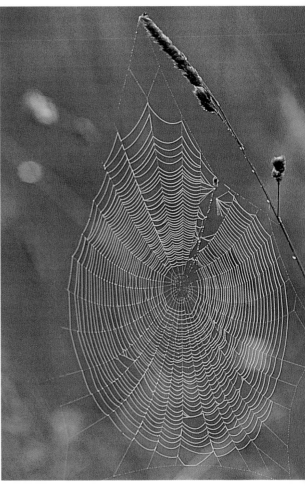

Spiderweb. *The left image was taken at f/16; the web is sharp, corner to corner, but the background is also sharp enough to be distracting. The one on the right was shot at f/5.6, taking care to keep the camera back parallel with the plane of the web. This shallow depth of field throws the background out of focus and eliminates it as a factor fighting for the viewer's attention.* M. L.

fly's wing in motion will be a blur on the film. At 1/500 of a second, you will obtain a reasonably sharp image.

Reciprocity

There is a reciprocal relationship between apertures and shutter speeds, so different combinations will allow the same amount of light to strike the film. If, for example, your meter recommends settings of 1/15 of a second at f/32, then all of the combinations listed in the table will yield identical exposures.

When you use a faster shutter speed, you are decreasing the amount of light striking the film. You can compensate for this by

Reciprocity	
Shutter Speed	Aperture
1/30 second	f/22
1/60 second	f/16
1/125 second	f/11
1/250 second	f/8

using a larger aperture, thus increasing the amount of light. This is an important concept to master, since it enables you to take a baseline exposure in the field and then change it to either stop action or increase depth of field, depending on which factor is more important to the particular image.

Metering
The metering system found in 35mm SLR cameras reads the light that is reflected back to the camera from the subject. The light meter compares the scene being photographed with an "average" scene—an outdoor scene in direct sunlight, which reflects about 18 percent of the light that falls upon it—and indicates which camera settings will yield the correct exposure. Eighteen percent reflectance falls halfway between the reflectances of white and of black, translating into a middle-toned gray. As long as the scenes being photographed have approximately 18 percent reflectance, the meter's recommendations will yield the correct exposures.

Autumn ferns in motion. *I was attracted to the golden color of these ferns near Old Forge, New York, in the Adirondacks, but was frustrated by gale-force winds. I finally decided to stop fighting the inevitable and used a slow shutter speed of 1/8 second to record the color, feeling, and movement of autumn. An 81A warming filter was used to accentuate the color.* M. L.

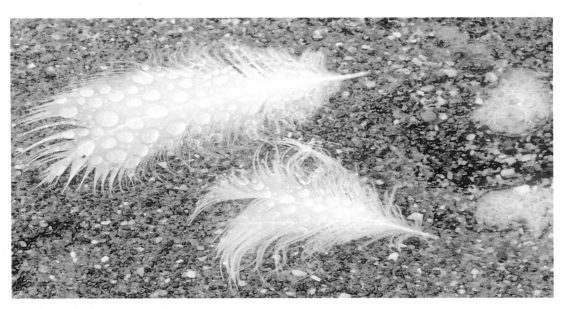

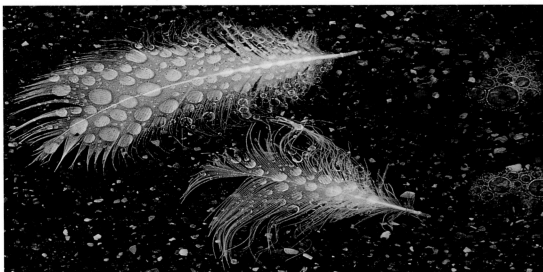

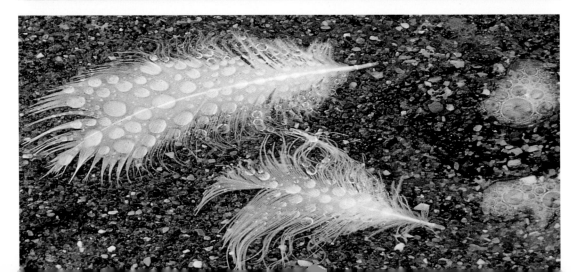

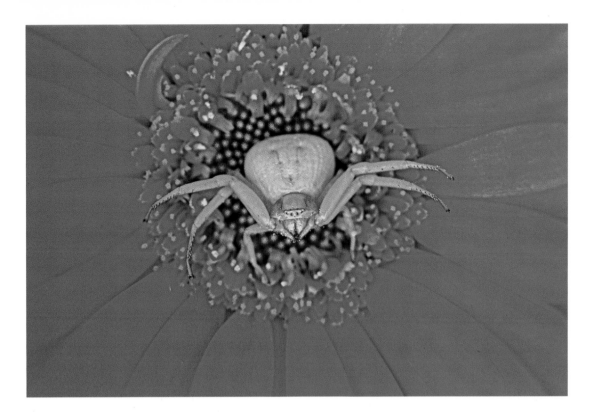

Above: Crab spider on cosmos. *A spot meter reads a very small portion of the image, often 1 to 5 degrees. This is very helpful in situations where there is a great deal of tonal variance within the scene, such as you might find with a light-colored flower in the midst of darker foliage, or a bright yellow crab spider on a dark red cosmos.* M. L.

Left: Feather on beach. *In the top image, the exposure reading was taken from the dark gray rock. The meter recommended settings that reproduced the dark gray into a middle tone, thus lightening the image and overexposing the feather. In the middle image, the meter reading was taken from the feather. Settings were recommended that made the white feather middle-toned and subsequently underexposed it. The bottom, and correct, exposure could be taken by metering from the rock and stopping down one stop, or by metering from the feather and opening up one stop. If the feather and the rock occupied equal areas of the frame, you could take an averaging reading and the exposure would probably be fine.* M. L.

But the world is not composed of ideally lit scenes, especially not in close-up photography. If you trust the meter's judgment, images photographed in deep shade are often too light and those photographed in bright sunlight are often too dark. To have your images accurately reproduce the tonality of the original subject, you must replace the meter's suggested settings with ones that will yield a more accurate or more pleasing rendition. To do so, you need to know what part of the scene your meter is measuring—the entire scene, a circle in the center of the viewfinder, or an area at the bottom of the viewing screen—and judge how much lighter or darker your subject is than middle tone.

You can estimate reflectance by taking a reading from a gray card, a piece of plastic

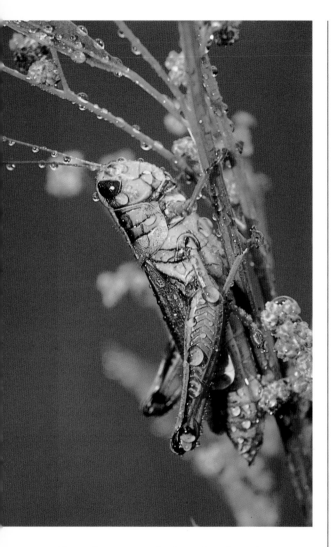

Yellow star of Texas. To obtain a correct exposure of this bright yellow flower, you can either meter on the flower and open up (add light) at least one stop, or meter from the medium-toned foliage and shoot at the settings your meter recommends. M. L.

or cardboard that reflects 18 percent of the light falling on it, or from the palm of your hand. In normal bright sunlight, your palm has a reflectance of about one f-stop lighter than middle tone, and in shade, about one f-stop darker. In sunlight, you can take a reading off your palm and stop down by using either a smaller aperture or a faster shutter speed to achieve a reasonably accurate exposure. Another way to determine the correct exposure is to find an area in the image that is middle-toned and meter from that area.

When using color transparency film, it's slightly more complicated than when shooting in black and white. The reflectance of colors varies according to hue and the intensity or purity of the color. The palette of greens, for example, ranges from that found in a dark pine grove, which may be two f-stops darker than middle tone and almost black, to a light mint green that may be almost white and two f-stops lighter than middle tone. When shooting color slides, you have only a one-and-a-half- to two-stop range (usually one f-stop lighter to one and a half stops darker than middle tone) before you begin to visibly lose image quality. To properly expose darker hues, you must stop down, using either a faster shutter speed or a smaller aperture to decrease the exposure. For light hues, you must open up, using a slower shutter speed or a larger aperture to increase the exposure. Fortunately for photographers, much foliage is middle-toned, or reasonably close to it. You must train your eye to recognize middle tone regardless of the color involved. Practice and take good notes.

Grasshopper with dew. Our farm in western Pennsylvania lies in a small valley, and the warm days and cooler nights of late summer bring us fog and early-morning dew almost daily. This grasshopper and its environment contain mostly medium tones. It was shot at metered readings, with fill flash at –1.5 to add sparkle to the dew. An aperture of f/11 was chosen to provide adequate depth of field without accentuating the background clutter. The magnification and all camera adjustments were set prior to stalking. M. L.

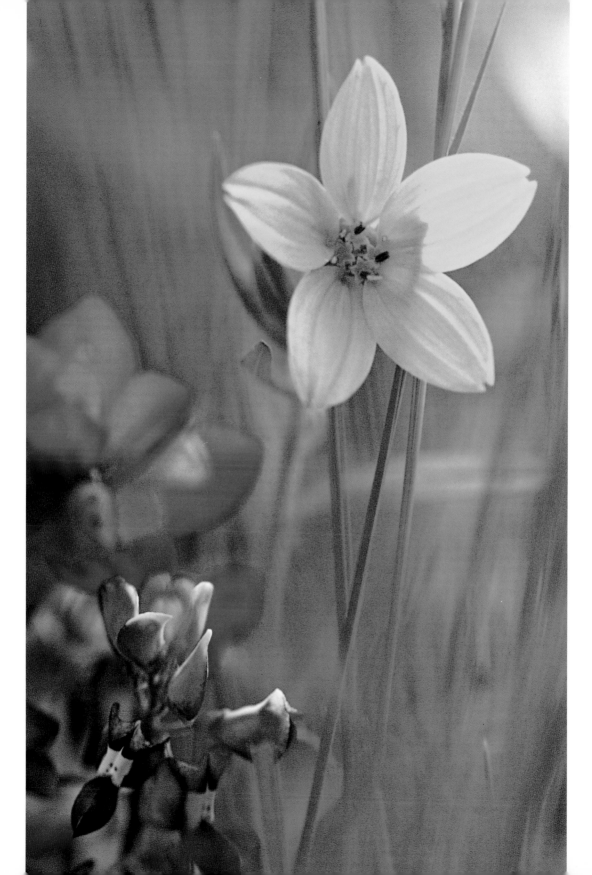

Exposing for Highlights

When you examine slides on the light table, it becomes immediately apparent that burnt-out highlights—those with no detail—are much more damaging to the impact and overall quality of an image than are blocked-up shadows and therefore must be given more attention when you plan your exposure. Thus when shooting slides, you need to expose for the highlights.

Highlights are the parts of an image that contain the lightest tones in which you'd like to see detail. Identify them and, if possi-ble, take your meter reading directly from this area. This is where a spot meter comes in handy.

Imagine that you are photographing bright yellow daisies. If you shoot at the meter's recommended exposure, the bright yellow petals will translate into a dull, mustard yel-low-brown. If you wish them to be more accurately rendered—lighter than middle-toned—you must increase your exposure accordingly. Take your meter reading from the petals and ask yourself how much lighter than middle tone the area is that the meter is

Barnacle and footprint. *When some species of barnacles are dislodged, they leave behind a "footprint" made of the calcified adhesive the barnacle uses to attach to its host. This image was exposed by spot-metering off the center of the white barnacle footprint and opening up one stop. Alternatively, I could have metered off the dark gray rock and closed down one stop. I prefer to use a highlight area as the basis of my exposure, as a burnt-out highlight will damage the impact of an image more than a darkened shadow.* M. L.

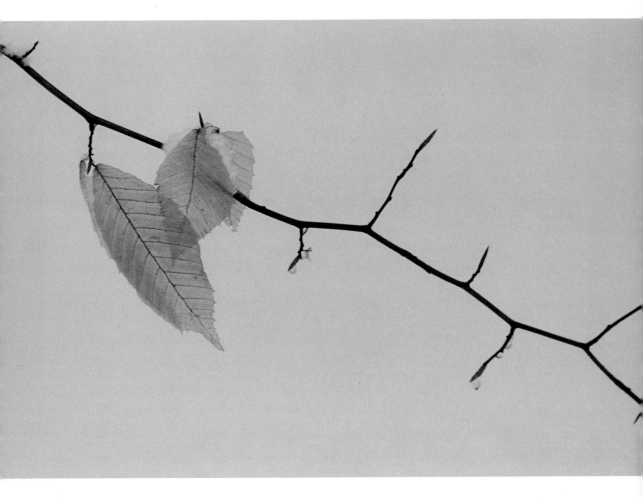

Leaves against snow. *Minimalistic in its simplicity of muted color and design, the interplay between the strong diagonal of the branch and the weaker diagonal intersection of the leaves contributes to a sense of balance in this image. Exposure was calculated by metering off the snow and opening up two and a half stops. Slight overexposure, sometimes referred to as "high-key" exposure, adds to the overall feeling of delicacy.* M. L.

reading. Suppose your meter reads 1/60 of a second at f/8 when you meter directly off the yellow petals. If you decide that the petals are one f-stop lighter than middle tone, you must open up one f-stop, exposing at 1/30 of a second at f/8 (a slower shutter speed) or 1/60 of a second at f/5.6 (a larger aperture). Both of these combinations will give you one f-stop more light than the meter's recommen-

dation and will produce a lighter and more accurate image of the daisies on film. This method is safest and most accurate when metering from a middle-toned area within the image.

To use this technique, you need to have a spot meter or the subject must be large enough to fill your meter's sensor area. What if you don't have a spot meter, or if the

Magnolia. The patterns of flower petals have always attracted me; their curves and contours lend themselves to studies in pure shape, color, and design. This magnolia was shot in Atlanta's Calloway Gardens. A diffuser was used to soften the light and avoid burnout of the highlights. A spot meter reading was taken from the center of the flower, which I felt was close to medium tone. Alternatively, I could have metered off the creamy white petal and opened up one stop. I did bracket two additional exposures, one a third stop over and the other two-thirds stop over the recommended reading, to make sure that I captured the creamy white tone of the center without burning out the lighter outside petals. M. L.

middle tone, close down one f-stop. The flower should then be properly exposed, and the spider also should maintain a proper exposure value.

If an image contains a contrast range greater than five f-stops (the range of tonality between the lightest and the darkest tones in the subject), you may still wind up with burnt-out highlights even though your middle-toned exposure is accurate, because transparency film cannot record a contrast range of more than five f-stops. You have to choose which of the tonalities present is the most important to the integrity of the image.

Once you've mastered the recognition of middle tones, you can use this awareness to transform a literal documentation of a subject into a more creative interpretation. You can purposely make your middle tones more pastel and high-key by opening up one-half to one f-stop, or you can saturate and enrich your colors by closing down. Remember, if your subject is lighter than middle tone, you must add light; if the subject is darker than middle tone, then subtract light. If you decide that depth of field is more important than freezing motion,

subject is only a small part of the entire image, such as a white crab spider on a dark red cosmos? If you take an averaging meter reading of the dark flower with the white spider, the meter will see mostly the dark petals and will tell you to lighten up to achieve medium tone. This will make the petals lighter than they are in real life and will overexpose the white spider. In cases like this, take your meter reading and then adjust the settings to match the predominant tonality present within the scene. If you judge the petals to be one stop darker than

leave the aperture set at the desired f-stop, and adjust your exposure by changing shutter speeds. If stopping movement is more important, choose the appropriate shutter speed first, and then adjust the aperture accordingly.

Bracketing

Bracketing refers to the practice of taking extra exposures in addition to the one that the meter recommends to help ensure that at least one of your exposures is the correct one. You can bracket in full, half, or third stops. If you're fairly confident of the exposure, you can bracket in just one direction. For example, if the subject is darker than middle tone but you're not sure whether it's a half or a full stop darker, you may bracket by closing down both one-half and one full f-stop.

If you're shooting in one of the automatic modes, such as aperture or shutter priority, bracketing is done very simply by using the exposure compensation dial on your camera body. Move the dial to the plus (+) setting to increase exposure for light subjects or to the minus (–) setting to decrease exposure for dark subjects. Be sure to set the dial back to the zero (0) setting after use, or all subsequent exposures will also be under- or overexposed.

Bracketing should not be used as a substitute for judgment. It is, however, a legitimate means of capturing at least one correct exposure of a special image. In certain difficult lighting situations, such as when dealing with highly reflective objects like seashells or certain beetles, bracketing may be the *only* way to obtain a good exposure.

Depth of Field

Depth of field refers to the range of sharpness in any image, extending from a point in front of the subject to a point behind it. Manipulation of this zone of sharpness is one of the most important artistic controls available to the photographer.

Factors Affecting Depth of Field

Depth of field is affected by magnification, focal length, aperture, and format.

Magnification

The greater the magnification, the shallower the depth of field at any given aperture. At f/16, depth of field at a magnification of 1:1 (life-size) is less than depth of field at a magnification of 1:2 (one-half life-size).

Focal Length

The longer the focal length of a lens, the greater the magnification and, because depth of field decreases as magnification increases, the less the depth of field at any given aperture. A 50mm lens at f/16 has greater depth of field than a 300mm lens at f/16, because it magnifies less.

Aperture

Depth of field decreases as the aperture diameter enlarges and increases as the aperture becomes smaller. Depth of field is therefore greater at f/16 than at f/5.6. When just starting out, it's useful to shoot your subjects at various f-stops to get an idea of the depth of field at different apertures.

In close-up photography, many factors conspire to decrease depth of field as we draw closer to our subjects. At higher magnifications, even a small aperture like f/22 may provide a zone of sharp focus of only 1/16 inch. In practical terms, this may mean that just the eye and head of a small butterfly are sharp, with the body and wings out of focus.

You can increase depth of field by stopping down to a smaller aperture, but be cautious. The smallest aperture will indeed provide maximum depth of field, but at f/22 or f/32, the opening in the iris diaphragm of the lens is so small that there may be diffraction of light at the edges of the diaphragm blades, causing optical or color distortion. The severity of this phenomenon varies from lens to lens. The only way to tell whether it affects a particular lens is to take pictures at the smallest aperture to see whether the diffraction effect is noticeable.

Format

Format refers to the actual film size and can range from subminiature Minoxlike film chips to 11×14 and larger sheet film. Depth of field decreases as format size increases. For instance, f/16 in medium format provides less depth of field than does f/16 in 35mm format.

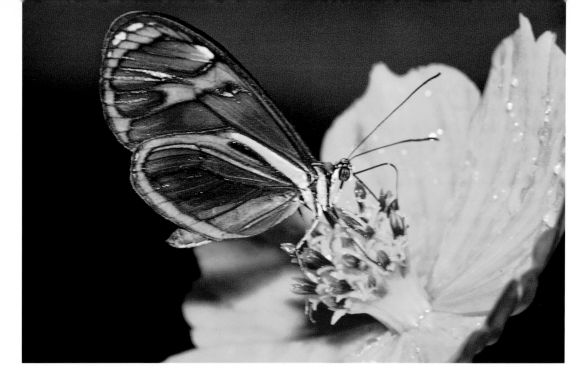

Tropical butterfly. *At a magnification of 1:1 (life-size), even f/32 may not maintain sharpness across an entire specimen. The eyes of this Ithomiinae, shot in Trinidad on Kodachrome 64 with full flash, are in focus, so you may not even notice that the wingtips are soft. The yellow flower provides a background so that the legs and antennae do not disappear into darkness.* M. L.

Parallel Planes

Imagine that there is a plane drawn through your subject and another through the camera back. If you orient these two planes so that they are perfectly parallel to each other, you will maximize your depth of field at any f-stop. This is especially important when shooting subjects that intersect many planes, such as spiders whose legs extend north, south, east, and west at the same

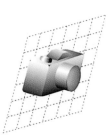
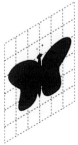

Parallel planes. *Imagine a plane drawn through the back of the camera and another through the subject. If these two planes are parallel, you can achieve maximum depth of field at any aperture. This is especially helpful when you wish to maximize sharpness but need to use a faster shutter speed, as when shooting flowers on a windy day.* COMPUTER GRAPHIC BY CHRIS POPOVIC

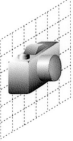

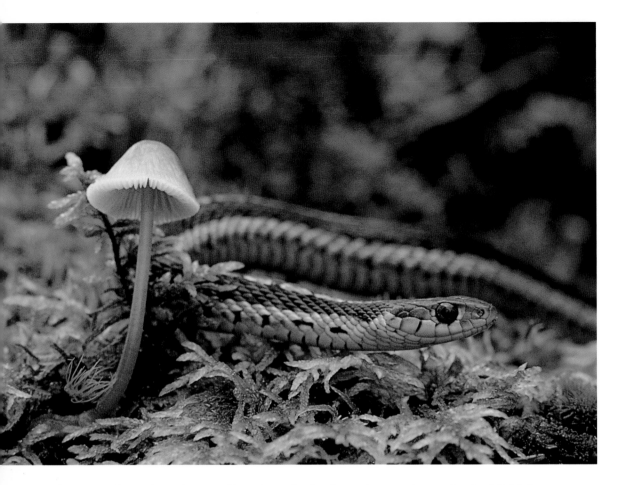

Garter snake and mushroom. *From an esthetic viewpoint, maximum depth of field does not always provide maximum impact. A shallow depth of field and more selective focus may allow a more impressionistic and poetic rendering of the subject. With living subjects, if the eye is in focus, we can accept quite a bit of unsharpness in the rest of the image. Here, the mushroom makes a nice counterpoint to the garter snake and evokes the forest floor. Shooting from eye level makes us participants instead of mere observers. I used a 200mm macro lens at f/5.6 to isolate the subjects and took care to keep the head of the snake in the same plane as the mushroom.* M. L.

time, and plants with blossoms that are thick or have protruding parts, such as columbine. If you have trouble visualizing these parallel planes, practice holding your hand at the subject plane and then comparing the plane of your hand to the imaginary plane that passes through the back of the camera.

Decide which parts of the subject are vital to your interpretation of the image. Orient your camera so that the plane intersecting these parts is parallel to the film plane. This will give you the greatest depth of field that your lens is capable of achieving at that aperture.

14

Below left: Frog in leaf. *Part of the art and skill of nature photography is the ability to locate subjects, which requires one to be a naturalist of sorts. If you know, for example, that one of the best places to find green tree frogs* (Hyla cinerea) *is inside the water-catching leaves of bromeliads, you have a better chance of finding one. Fill flash at −1.5 was used to bounce light inside the confines of the leaf, and a shallow depth of field was used to throw everything except the frog's eyes out of focus.* M. L.

Below right: Galactic web. *The upper image was taken at f/22 and thus shows extensive depth of field, yielding a totally confusing and unfocused image. The lower image was shot at f/4. Because the depth of field is so shallow, only a few of the dewdrops are sharp; the remainder of the image is out of focus and pleasingly blurred. This treatment is more suitable for an abstract than a documentary photograph.* M. L.

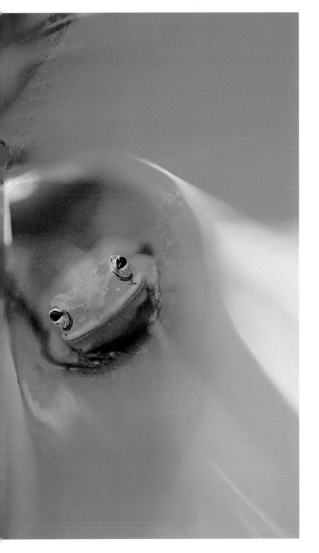

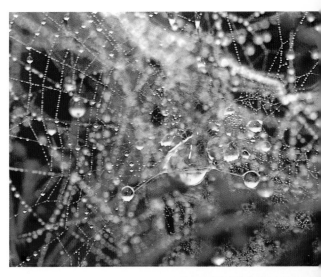

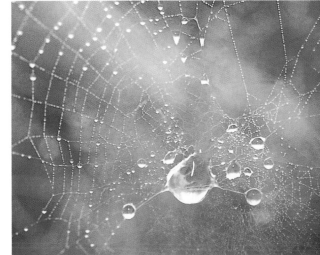

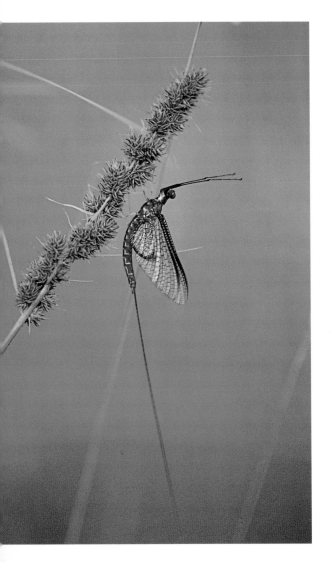
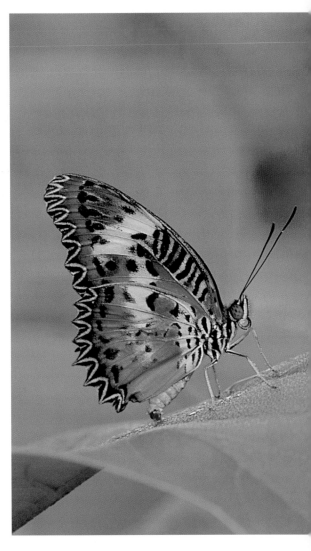

Above left: Mayfly on grass stem. *The peacefulness of this image, shot during a mayfly hatch in eastern Ohio, belies the hysteria of the actual event. Millions of these ephemeral insects were underfoot. The major challenge lay in isolating one particular subject. A 200mm lens was used to compress background and foreground, and the image was exposed at f/8 to provide shallow depth of field. The film plane was parallel to the plane of the mayfly's body to maximize the zone of sharpness. The out-of-focus soft color surrounding the mayfly serves to emphasize its exquisite detail.* M. L.

Above right: Butterfly laying egg. *Aligning the film plane with the subject plane allowed me to maximize depth of field while using a large aperture to throw the backgound out of focus. The soft-colored background is in contrast with the vibrant colors of the insect itself, accentuated by the saturated palette of Fujichrome Velvia.* M. L.

Determining Depth of Field

You can vary the emotional impact of an image by changing the depth of field. To achieve the sharpness and detail required for biological documentary portraits, for instance, you must shoot at very small apertures for maximum depth of field. For a more impressionistic quality, when the feeling of an image is more important than the detail, you can open up and shoot at larger apertures. When shooting living creatures, if you keep the eye of your subject in focus,

Frog prince in club moss. *This photograph was taken during one of our spring macro workshops at Raccoon Creek State Wildflower Preserve. I wanted to portray the essence of "frogness" with a personality portrait rather than a standard documentary shot. I chose to show this potential prince as a regal predator, shooting from the prey's viewpoint. This type of image would never find its way into a guidebook, but it was exactly what I had in mind. Exposure was based on a spot meter reading from the medium-toned foreground moss. I chose a shallow depth of field to minimize foreground and background distraction and focus the viewer's attention on those large, all-seeing eyes. Fill flash, angled from the upper left to simulate sunlight, added sparkle to the moist skin and detail to the eyes. A gold reflector was used to bring out the gold flecks in the eyes. The club moss was a bonus, but the camera angle was deliberately chosen to include the out-of-focus purple violet that adds a splash of color to the background.* M. L.

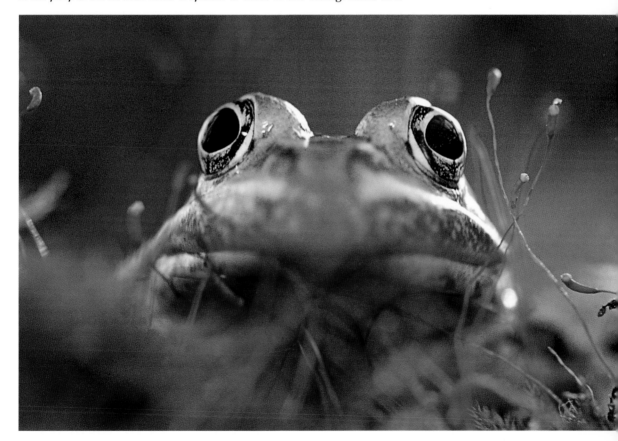

you will often achieve an acceptable image even if the rest of the body is unsharp.

When you look through the viewfinder, the lens is open to its widest aperture for focusing. Depth of field is always shallowest at this focusing aperture. If you wish to see what the foreground and background will really look like in your final photograph, and just how sharp the subject will really be, you must stop down to the shooting aperture using the depth-of-field preview button. This is one of the most vital functions offered by your camera.

As you press the depth-of-field preview button, the image becomes quite dark at the smaller apertures. In fact, at f/22, most detail may be obscured, making it very difficult to judge what is sharp. Pressing the depth-of-field preview button while the aperture is wide open and then slowly closing down to the desired shooting aperture will allow your eye to adjust to the decreasing light.

Because the depth-of-field preview button lets you evaluate backgrounds and foregrounds at the shooting aperture, it gives you the information you need to change position in order to avoid busy surroundings that distract from your main subject. It is thus a vital esthetic tool in your photographic arsenal. We would not buy a camera that did not have one!

Equipment

With any of the modern name-brand cameras, you should be able to produce satisfactory photographs. There are certain features and characteristics, however, that make some camera systems better for close-up photography than others.

Cameras

Cameras are classified according to viewing system and format. The viewing system describes the arrangement of prisms and mirrors within the camera body. Format refers to the size of the transparency or negative that the camera accepts. The 35mm single-lens reflex (SLR) is by far the most convenient choice for close-up photography.

35mm Format

Today's 35mm cameras are relatively small and lightweight, with many accessories designed specifically for close-up photography, making them ideal as field instruments. There are many types of 35mm film available, and frame for frame, it is the least expensive and also allows many exposures before reloading. The downside of 35mm is that the image area measures only 1 inch by 1^1/$_2$ inches, so any significant enlargement causes some deterioration of image quality, although with modern fine-grain films, you can make enlargements of up to 11×14 without much loss in quality.

Medium Format

Medium format is the next step up in size from 35mm and includes 6×4.5cm, 6×6cm, 6×7cm, 6×17cm, and panoramic images. Because of the larger size, medium format provides better quality when enlarged. It is more expensive per frame than 35mm, and you get fewer shots per roll. Dedicated macro accessories, such as through-the-lens (TTL) flash and telephoto-macro lenses, are unavailable for most medium-format cameras. Some macro lenses may be optically corrected for these cameras, but the degree of magnification without the addition of extension or close-up lenses may be limited. Nevertheless, some photographers, such as Heather Angel and Jim Zuckerman, routinely produce superior work in medium format; if you need 16×20 prints of your close-up images, you may want to consider a medium-format system.

Large Format

Large-format images are 4×5 inches and up. The view camera image is seen on a ground glass, not through a viewfinder, and is upside down and reversed left to right. This is fine for scenic or landscape photography, but imagine trying to maintain focus on a hopping frog, upside down and backward. View cameras are expensive, heavy, and

generally load only one sheet of film at a time. There is no TTL metering. If, however, you are interested in natural still-life photography, look at some of Eliot Porter's photographs to see what exquisite close-up images can be captured with large-format equipment.

Camera Features

When you purchase a camera, you are not just buying a piece of equipment; you are buying into an entire system. Do your homework and make sure that both the specific camera body and the system itself provide the features you may want as your interest and skills grow. No matter which format and brand you decide on, there are certain features that will make your life simpler in the field.

Interchangeable Lenses

Most "serious" camera systems manufactured today offer a variety of lenses. If your interest is in close-up photography, make sure that the system includes one or more macro lenses.

Depth-of-Field Preview Control

Landscape photographers can often accurately estimate depth of field because the distances they deal with are forgiving. When shooting a mountain range, when depth of field can be measured in miles, you may not see much difference between f/16 and f/32. In macro, however, at 1:1, the entire depth of field may be $1/16$ inch or less. A depth-of-field preview control, either electronic or manual, allows you to evaluate the depth of field through the lens before releasing the shutter. Recently, some camera manufacturers have decided that this is a superfluous feature and have not included it on some of their newer models. But for close-up photography, especially for macro, try hard to find a camera body that has depth-of-field preview capability.

Through-the-Lens Metering

Through-the-lens metering simply means that the camera's meter reads the light reflected from the subject. This is a standard feature in all SLR cameras manufactured today.

Interchangeable Focusing Screens

Camera bodies often come from the factory with focusing screens that have some type of focusing aid built in, such as a split-image finder or a microprism spot. These can be distracting, however, and can even black out at small apertures. For our close-up photography, we prefer a plain matte screen, with a grid to aid composition. The light-gathering focusing screens from Beatty and Brightscreen can be very helpful when focusing in dim light. Many other manufacturers specially coat their screens to increase light transmission.

Remote Operation

Your camera should accept either a mechanical or an electronic cable release. This allows remote firing and avoids jarring the camera, thus eliminating another cause of vibration, especially important for close-ups.

Self-Timer

A self-timer can be a great help when you forget or lose your cable release. If wind moves the camera, however, or if the light changes during the exposure, the result may not be what you expected.

Lenses

Normal Lenses

The normal lens is so named because it most closely imitates the human eye's angle of vision, approximately 45 degrees. These lenses are less than ideal for close-up photography, however. They are engineered to achieve optimal quality at "normal distances," generally between 10 feet and infin-

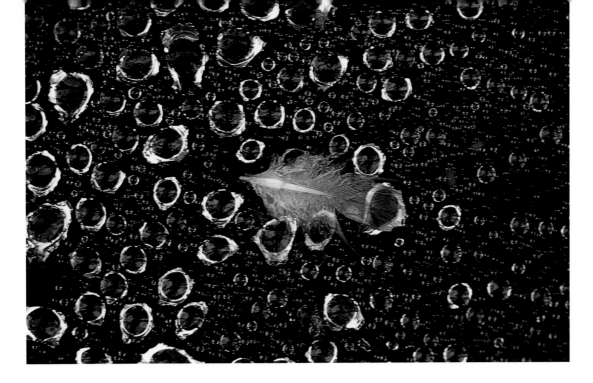

Feather in web. *A 50mm macro lens works fine with a still-life subject, where camera-to-subject distance is not a problem. The film plane was set up parallel to the plane of the web, and a shallow depth of field was chosen to isolate the dewdrops and feather against the cluttered background. Fill flash at −2 was used. This shot was bracketed in one-third-stop intervals, as it was difficult to predict the effects of flash on the thin strands of spider silk and dewdrops.* M. L.

ity. Many normal lenses exhibit optical aberrations or curvatures of field that are not apparent at normal distances but become visible when the lens is focused at distances closer than 2 or 3 feet. This results in images that are sharper at the center than at the edges.

The average 50 or 60mm lens has a close-focusing distance of 18 to 24 inches. Though this may be fine for still-life photography, you are likely to scare away many small subjects at such close range, and your body may block the available light. A longer focal length, such as 105 to 200mm, will give you and your subject more room in which to maneuver. This is particularly important when your equipment is tripod-mounted.

Most normal lenses achieve a maximum magnification of only 1:8 (one-eighth life-size) or 1:10 (one-tenth life-size). If you divide your 1-by-1 1/2-inch area (the size of a 35mm slide) into ten parts, and then fit the subject into one of those parts, this will give you an idea of how large your final image will be.

Macro Lenses

Macro lenses offer magnifications of at least 1:2 and sometimes 1:1, with minimum focusing distances of 8 to 12 inches without the use of accessory devices. They are corrected for shooting at close distances, minimizing optical distortion. They are called flat-field lenses because their plane of sharp focus is not curved, providing images that are as sharp at the edges as they are in the center.

Macro lenses are manufactured in various focal lengths. A 50mm macro lens can dou-

ble as a normal lens, and the newer ones are just as sharp at normal working distances as they are close up. Their disadvantage is that you must be fairly close to your subject in order to achieve higher magnification. They are perfectly adequate, however, for still-life, flower, or table-top photography.

Ninety to 105mm macro lenses are thought by many to be ideal focal lengths. These moderate telephotos provide more working space between you and your subject and often allow one-half to full life-size at 18 to 24 inches, fine for many small creatures such as butterflies and frogs. They

Wasp on goldenrod. *The left image was taken with a 105mm macro lens from about 10 inches, with a magnification of 1:3. Exposure was determined by metering off the bright yellow goldenrod and opening up one stop, since the goldenrod is approximately one stop brighter than middle tone. The image on the right was taken with the 200mm macro lens, providing the same magnification from about twice the distance. The added length of the 200mm macro allows more distance between photographer and subject or greater magnification at the same distance.* M. L.

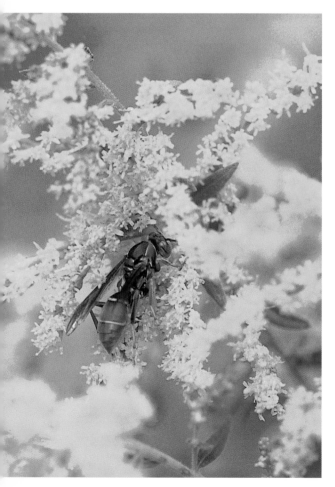 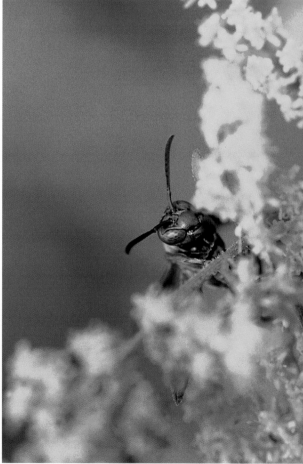

also provide a nice focal length for portraits and scenics. If we had to choose just one lens, a 100 or 105mm macro would be it.

One hundred eighty to 200mm macro lenses are more specialized. They allow even more working distance between you and your subject and are ideal for shy or aggressive subjects. You might shoot cobras, for instance, with a 200mm macro lens. Like all telephoto lenses, they compress foregrounds and backgrounds and help isolate the subject, thereby increasing impact.

Macro lenses are usually slower than their normal counterparts. Whereas normal lenses may have maximum apertures of f/1 to f/2, macro lenses generally have maximum apertures of f/2.5 to f/4. This is not a major problem, since you'll usually be shooting at small apertures anyway to maintain good depth of field.

Telephoto Lenses

Your normal telephoto lens can be pressed into service as a macro lens by adding a small extension tube. By doing so, you change the close-focusing distance of the lens, thus allowing for greater magnification. For example, a 300mm lens may have a close-focusing limit of 15 to 20 feet. If you add a 25mm extension tube, you may now be able to focus as close as 7 feet, with increased magnification. This range is excellent for butterflies or reptiles and amphibians. The quality of the image depends entirely upon the optical quality of the lens. This is a cost-effective technique, as a full set of automatic extension tubes, usually three tubes in a set, should not run more than $100. One disadvantage is that when you add a tube to a normal telephoto, you lose the ability to focus to infinity.

Telephoto Macro Zooms

Though many telephoto zoom lenses are labeled "macro," their maximum magnification is often only 1:4 or 1:5. Top-quality tele-

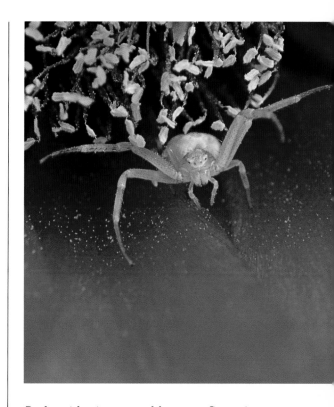

Crab spider in cactus blossom. *Capturing a specific behavior pattern at the moment of expression can make the difference between a ho-hum documentary and an image with impact. This crab spider was alarmed by my approach and adopted a warning posture. A 200mm macro lens brought me to approximately 12 inches from the subject. I used a reflector to fill the shadows inside the flower without overexposing the light-colored crab spider. The reflector has an advantage over flash in that you can see the results through the viewfinder before making the exposure.* M. L.

photo zooms in the 80–200mm range can be pressed into macro service by adding an extension tube, telextender, or close-up lens. One well-known nature photographer does consistently excellent work with an 80–200mm f/2.8 zoom and a 2X telextender

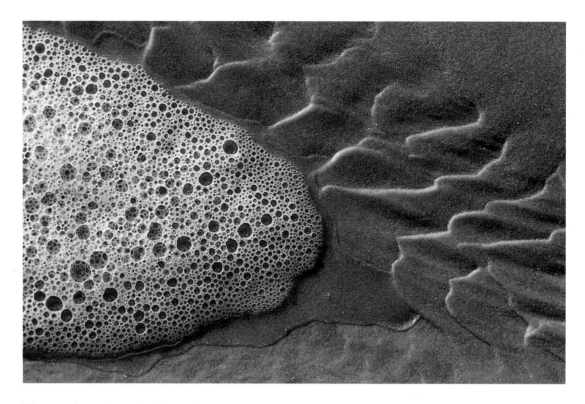

Wave and sand ripples. *In early morning, the sun is low on the horizon and its light is very directional, exaggerating texture and creating a golden glow. Shot on the beach at Corpus Christi, Texas, this image portrays the contrast between two rather ephemeral entities. Ripples in the sand seem short-lived until we compare them with the bubbles in a wave, which are truly the work of an instant. I used a 200mm macro lens to pick out detail while maintaining a good working distance, and E100S film to allow the use of a reasonably fast shutter speed.* M. L.

made by the same manufacturer. This provides a 160–400mm f/5.6 lens—a great range for small creatures and still a fairly fast setup. Stop down at least one stop and either use flash or keep the system on a tripod for best results.

Wide-Angle Lenses
Lenses 35mm or wider can be used for super-macro shots with a very different perspective. Put the wide-angle lens on a short extension tube, get really close to your subject, and use the wide-angle perspective as a feature of the composition.

Optical Accessories

Telextenders
Telextenders are supplementary lens that can be added between the prime lens and the camera body. They change the optical configuration of the lens and subsequently increase magnification without affecting depth of field or shooting distance. Since the light has to travel through additional optical elements before striking the film, some light is lost in transmission: one stop with the 1.4X telextenders, two stops with the 2X units. The best ones today are made

Telextenders		
Prime Lens	1.5X Telextender	2X Telextender
50mm f/2.8	75mm f/4	100mm f/5.6
100mm f/4	150mm f/5.6	200mm f/8
200mm f/4	300mm f/5.6	400mm f/8
80–200mm f/2.8	120–300mm f/4	160–400mm f/5.6

Grasshopper on cosmos. *To capture this little grasshopper on its perch without disturbing it, I needed maximum magnification from maximum distance. The normal close-focusing limit of my 400mm f/3.5 telephoto lens is about 15 feet, at which distance this little guy would be a barely discernible bump on a small, red blob. By attaching a 50mm extension tube to the lens, I was able to shoot from a distance of 4 to 6 feet.* M. L.

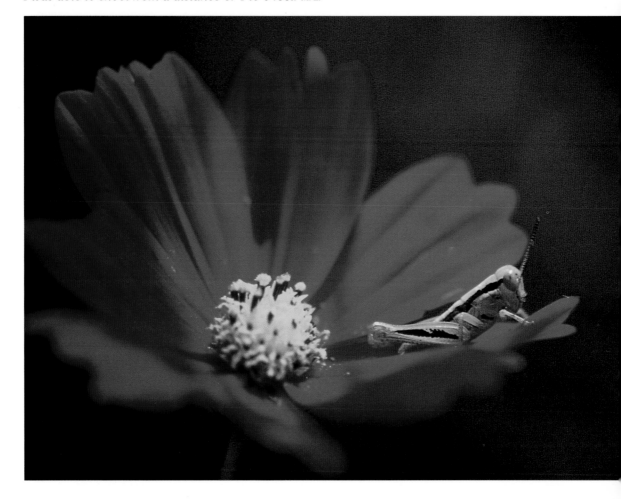

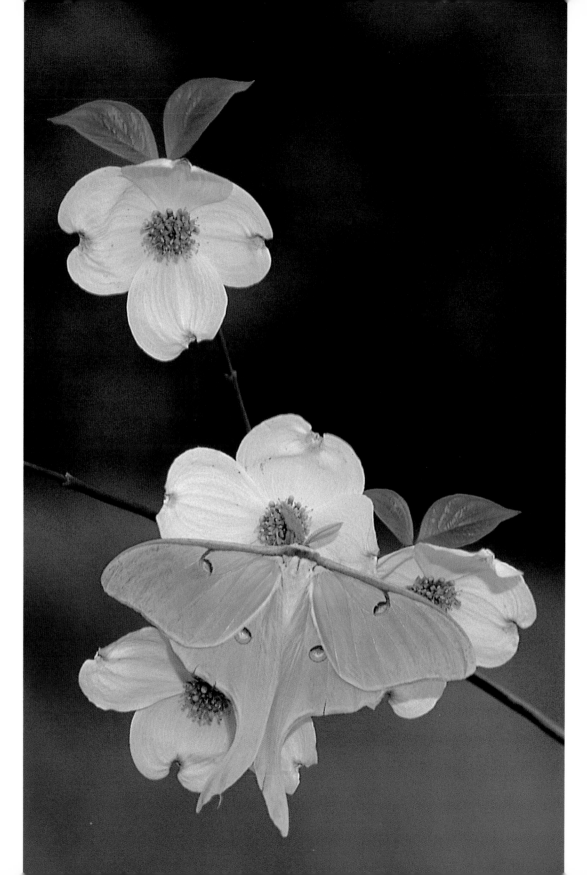

Close-up diopters			
Diopter Strength	85mm	105mm	200mm
+1.5	1:4	1:3	1:2
+3	1:3	1:2	1:1.4
+1.5 plus +3	1:2	1:1.5	1:1

to optically match the same manufacturer's prime telephoto lenses, and the quality is excellent. It's still best to stop down at least one stop, although the better ones offer fine results even at the widest aperture.

Close-up Lenses

Like filters, these screw onto the front of any lens. The only ones worth buying consist of two or more glass elements; their optical quality is quite good, and they are in the $30 to $50 range. The sets of three close-up lenses advertised for $50 per set are single-element lenses (actually just magnifying glasses in screw mounts) and are not for serious photography. Generally, the lower the power of the close-up lens, the better the contrast and resolution. A close-up lens

Luna moth *(Actias luna)* on dogwood. *These large silk moths live only to get their genes into the next generation. They have no mouthparts and do not eat, so if you see one on a flower, it is either resting or laying eggs. This luna posed on the dogwood branch long enough to be immortalized on film. I was struck by the balance and delicacy of the subject and strove to isolate it from foreground and background by choosing f/8 for a shallow depth of field. A 1.4X telextender was used to further compress the background. The upper dogwood leaf acts as a counterbalance to the moth on the blossoms below, and the image is stabilized by the lower subjects (moth and blossoms) appearing heavier than the upper leaf.* M. L.

may be used on any prime lens that has matching filter threads, regardless of manufacturer or focal length.

Right-Angle Finders

Right-angle finders are miniperiscopes that attach to the eyepiece of your camera and allow you to shoot at very low levels without getting your ear in the mud.

Tripods and Accessories

A good tripod is a long-term investment. Next to your camera and lenses, your tripod is your most important piece of equipment. Its support allows for sharp images even in the dim lighting conditions you will often encounter in the field.

Tripods are available in various materials, all of which have their advantages and disadvantages. Aluminum tripods are lightweight and relatively inexpensive. They are sturdy and easy to maintain but do require some maintenance and periodic dressing with WD-40 or similar lubricant. They can become pitted if exposed to salt water. Wood tripods are heavy but esthetically pleasing. Wood is a good insulator and comfortable to use in cold weather. Carbon fiber tripods are lightweight but expensive. Vibration due to decreased mass may be a potential problem, especially with longer and heavier telephoto lenses.

Choose a tripod that extends high enough for you to be able to look through your camera at eye level without stooping or extending the center post. For close-up photography, the legs should move indepen-

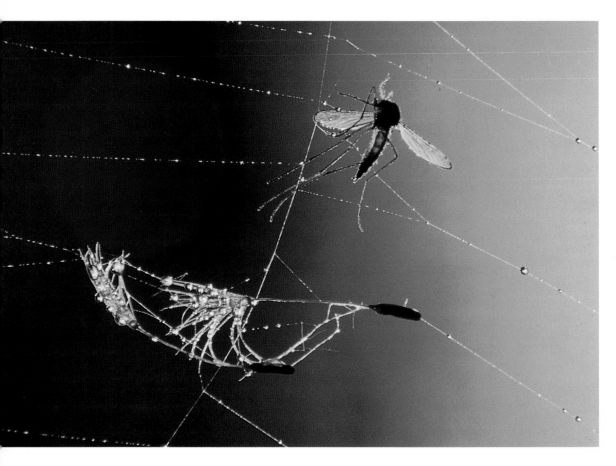

Mosquito and dandelion seed in spider web. *This web had picked up some flotsam and jetsam during the warm day, and then collected condensation during the chilly morning hours. This photograph, taken near Hamilton, Ontario, was an exposure challenge. I used fill flash at a very low intensity (–2) and bracketed in one-third stops to maintain the backlighting provided by the rising sun without burning out the highlights in the dewdrops. A wide aperture (f/5.6) prevented the octagonal flare that occurs when shooting directly into the sun with a small aperture. A 5T close-up lens on my 200mm macro lens provided greater-than-life-size magnification.* M. L.

dently, and you should be able to collapse the entire mechanism to ground level, so avoid tripods with braces between the legs and the center column. Also avoid high center posts, which destabilize your tripod by converting it into a monopod with three legs. You can buy a short center post as an accessory, or use a hacksaw to cut down a long one. Round legs are stronger than those with a U-channel design, and in general, the fewer the number of leg sections, the better. Make sure the tripod is assembled with screws, not rivets, so you can take it apart for periodic cleaning.

The tripod head is the part that attaches the camera to the tripod. The two most common varieties are pan-tilt heads and ball heads. Pan-tilt heads have different

handles to control the movement of the camera and lens. The handles allow movement in only one plane at a time and may be cumbersome and slow to use in the field. These heads are relatively inexpensive. Ball heads are somewhat more expensive and often heavy, but they are more useful for close-up photography because of their ability to move rapidly in all planes.

There are several other types of tripod heads—fluid-filled, gimbal, and so on—but they are not commonly used for macro.

Whatever the type of tripod head, you should use a quick release, a device that attaches to the top of the tripod head and accepts a plate that then attaches to the bottom of the camera or lens. This arrangement allows you to quickly and easily attach and detach the camera or lens. In the field, you don't want your subject to take off while you're busy screwing your camera or lens onto your tripod. The Arca-Swiss plate-and-clamp design is state of the art, and the custom plates made by Bryan Geyer at Really Right Stuff are beautifully machined to fit just about any camera or lens.

Camera Bags, Packs, and Cases

Once you've acquired all your photo gear, you'll need something to carry it in. There's no one best choice; your requirements will vary with each photo shoot. Whatever you decide upon, make sure that it's comfortable and holds what you need with convenient access.

A shoulder bag is well suited to shooting from a vehicle. It is not quite as useful if you are on foot, as it puts a lot of weight on one shoulder, which can become quite uncomfortable over long distances. Here, a backpack with an internal suspension frame, hip belt, and padded shoulder straps is better, as it allows you to carry huge loads with minimal effort. We currently use a Sundog Medium pack, which holds all our gear plus lunch and jackets and fits in an overhead compartment on a plane. For day trips with a minimal amount of gear, a combination of vest and fanny pack will often suffice.

The soft-sided shoulder bags and backpacks are tough, but they are not designed to be luggage. If you're traveling by plane and must send equipment by baggage, use a Halliburton, Tundra, or Pelican-type suitcase. These offer the best protection, but they are easily recognizable by thieves as containing camera equipment. Disguise them by packing the photo suitcase in an inexpensive, tourist-type, soft-sided case. Most airlines are tightening up on carry-on baggage restrictions. If you buy a bag or pack to use as a carry-on, make sure it satisfies the space requirements.

Magnification Devices

Magnification is simply a comparison of the size of the subject in real life to the size of its image on film, expressed as a ratio or fraction. A magnification ratio of 1:1, or life-size, means that a subject that is 1 inch long in real life will also measure 1 inch on film. A magnification ratio of 1:2, or one-half life-size, means that a subject that measures 1 inch in real life will measure 1/2 inch on film.

The actual area covered by a 35mm transparency at 1:1 measures 1 by 1 1/2 inches, the measurements of the image area of the slide itself. At 1:2, the field encompassed by the image will measure 2 by 3 inches in real life and 1/2 by 3/4 inch on film. The higher the magnification of the subject, the more space it will occupy on the slide, at the expense of the size of the field, or environment. Thus if you want to include some habitat, you must use a lower magnification. Environmental portraits often have more impact than super close-ups where you can count wing scales.

Extension Tubes and Bellows

As you move a magnifying glass farther from a subject, the magnification increases. You can similarly increase photographic magnification by physically increasing the film-to-lens distance with extension tubes or bellows.

Extension tubes are hollow metal tubes that attach between the camera and lens. They couple to the camera body using the same type of mount as the lens, which is then attached to the other end of the extension tube. Extension tubes are manufactured in different lengths, ranging from 10 to 50mm. The longer the tube or combination of tubes, the greater the degree of magnification.

Extension tubes are lightweight, inexpensive, and sturdy, and with the more modern tubes, you maintain most automatic functions, such as through-the-lens metering. Disadvantages are that you are limited in magnification to the combinations of tubes available, and it takes time to couple and uncouple the tubes, during which an active subject may leave. Most tubes are manufactured in a fixed length and provide a single magnification range with any particular lens, although there are several variable-length extension tubes on the market that are more versatile.

Whether you buy individual tubes or a set, make sure they are compatible with your camera. The older extension tubes produced by several manufacturers cannot be used with the same manufacturers' newer electronic bodies and, in fact, may damage the mechanical or electrical contacts.

Extension bellows serve the same function as extension tubes, increasing magnifi-

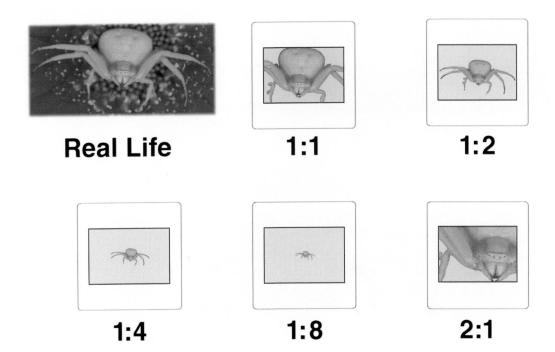

Real Life **1:1** **1:2**

1:4 **1:8** **2:1**

Magnification composite. COMPUTER GRAPHIC BY CHRIS POPOVIC

cation by increasing film-to-lens distance. A bellows unit consists of front and rear standards, which couple to the lens and camera body joined by a flexible, accordionlike extension. A bellows unit is essentially an infinitely variable extension tube. The advantage lies in the ability to change magnification in small or large increments without the need to uncouple the unit from the camera. Because of their greater overall length, bellows units also provide more extension than a set of extension tubes, thus allowing a greater degree of magnification. With shorter focal-length lenses such as 50 or 60mm, a bellows can provide magnifications well over 1:1. They are, however, somewhat more delicate, cumbersome, and expensive than extension tubes. In addition, many do not provide automatic diaphragm operation, but require either a double cable release or

manual closing of the diaphragm to the correct aperture before exposure. There are no bellows units at this time that maintain autofocus capabilities, but there are several variable-length extension tubes that do.

Neither extension tubes nor bellows contain optical glass elements. The quality of the image is determined only by the optical quality of the prime lens.

When using any extension device, the increase in magnification is due to the ability of the lens to focus closer and is expressed by comparing the amount of extension with the focal length of the prime lens. This holds true for wide-angle lenses as well as telephotos. A 50mm extension tube on a 25mm lens results in a 2X, or twice life-size, magnification. The chief drawback here is a significant decrease in lens-to-subject distance. At that magnifica-

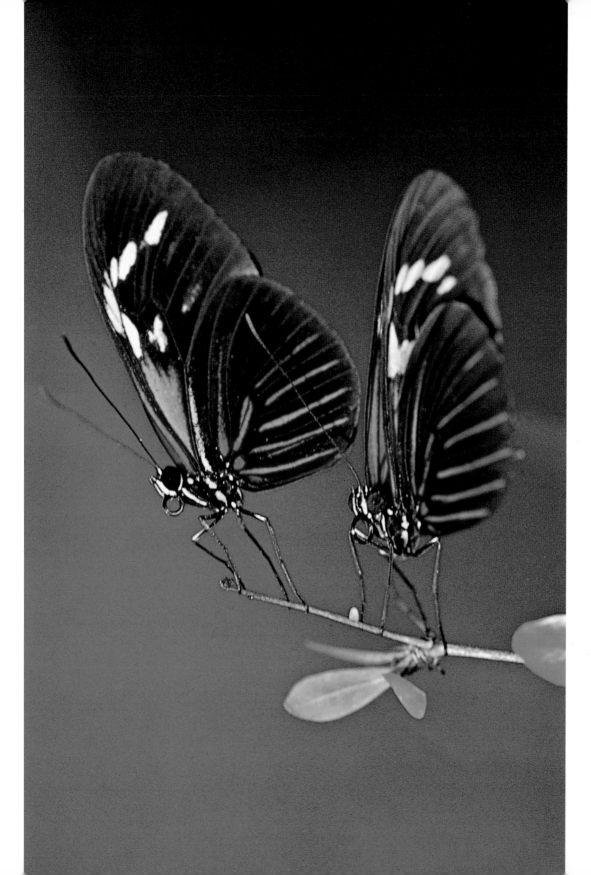

tion with a 25mm lens, you will be perhaps 2 inches from the subject. Even if you are photographing inanimate subjects, such as postage stamps, the proximity of the camera to the subject can make lighting difficult. Shorter tubes, however, can yield very dramatic images when used with shorter focal-length lenses, such as those in the 20 to 35mm range. Shooting flowers at ground level with this combination can yield images that are quite different from the routine floral portrait.

Reversing Rings and Stacking Rings

Most normal lenses are constructed with asymmetrically placed elements and are designed to give their best optical perfor-

Left: Two butterflies. *Selective focus and a relatively shallow depth of field (f/8) isolate these two butterflies as they seemingly get ready for a sprint to the next blossom. A magnification of 1:2, with its more shallow depth of field, was chosen to exclude distracting elements, and impending movement is suggested by both the posture of the insects and the space in front of them. Fill flash at −2 was used to fill shadows and add just a bit of snap to the image. Shot at the Butterfly House at Calloway Gardens, Atlanta.* M. L.

Below: Ice designs. *The amoeboid shapes of air bubbles trapped under the ice of Lake Erie give no hint as to their size and are examples of pure abstraction. A 105mm macro lens with a short extension tube yielded a magnification of greater than 1:1 and the resulting shallow depth of field helped isolate the design from any frame of reference.* M. L.

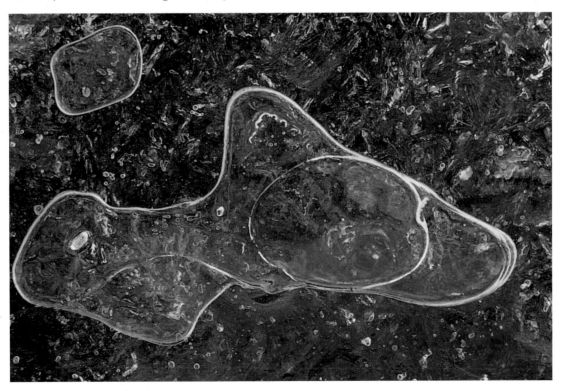

mance at normal viewing distances of about 8 inches to infinity. Optical performance may deteriorate when the lens is used at distances closer than normal. Reversing the lens on the camera face plate, with the aid of a reversing ring, increases magnification and may actually improve image quality. A reversing ring is an adapter that mounts to the camera on one side and the front of the lens on the other.

Automatic functions are lost when the lens is reversed, so the lens must be stopped down to the correct shooting aperture either manually or with a double cable release made specifically for that purpose. Filters cannot be used in the normal fashion, and exposures must be made in a manual or aperture-priority mode. Magnifications well over life-size are possible using this technique, and the optical quality is generally quite good.

A variation on this theme can be achieved by using stacking rings to attach one lens, reversed, to the front of another. The best optical results are obtained by attaching the longer lens to the camera and reversing the shorter lens. Essentially, you are transforming the shorter lens into a highly corrected, multicoated, multielement magnifying lens.

Autumn leaf. *This autumn leaf fragment, shot on Fujichrome Velvia with an 81A warming filter to saturate the colors of fall, represented to me the entire season. A 200mm lens was used to isolate a section of the leaf at 1:1. Shooting at life-size magnification creates effective abstractions by eliminating any frame of reference other than the color, texture, and pattern of your subject.* M. L.

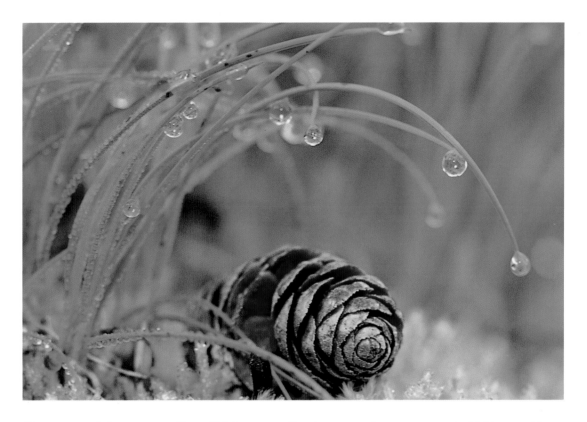

Pinecone and dewy grass. *Use of higher magnifications can give you access to hidden worlds and allow your imagination to run wild. Can you see the wood elf hiding behind this tiny pinecone?* M. L.

The shooting aperture is set on the longer lens attached to the camera, and the shorter, reversed lens is set at its largest aperture. With this technique, all automatic functions still work, as the longer lens is attached to the camera in the normal fashion. To calculate the magnification of stacked lenses, divide the focal length of the longer lens by the focal length of the shorter one (see the table on page 36).

Shooting at higher magnifications of 3X and greater is often more suited to an indoor studio than to the field. At such magnifications, the vibration from your pulse or the smallest breath of wind, even if you use a sturdy tripod, can cause a loss of sharp-

ness, and any unsharpness will be magnified along with the subject.

When a lens is reversed, all the delicate mechanical and electrical contacts on its rear are now exposed. To protect it, you can cut out the bottom of a rear lens cap and glue a rubber lens shade to it.

Other Devices

If you wish to further explore the realm of higher-magnification close-up photography (3X to 10X), several camera manufacturers produce short focal-length lenses, from 20 to 45mm, specifically designed for this purpose. Some have focusing helices like normal lenses. Others do not and are

Magnifications of stacked lenses		
Prime Lens	Reversed Lens	Magnification
200mm	100mm	2X
200mm	50mm	4X
200mm	35mm	5.7X
200mm	24mm	8.3X
100mm	50mm	2X
100mm	35mm	2.8X
100mm	24mm	4.1X
50mm	35mm	1.4X
50mm	24mm	2X

intended for use on a bellows. All have manual diaphragms and must be stopped down manually to the shooting aperture. Although mechanically and electronically primitive, they are highly corrected optically and are capable of delivering superb results if used properly. At these high magnifications, most are more suitable for indoor work under controlled conditions than for fieldwork.

Enlarging lenses, which are already highly corrected for flat-field imaging, can also be attached to a bellows with the appropriate adapter ring. These lenses have manual diaphragms but are capable of very sharp results at higher magnifications.

Filters

Light, as we see it, is a mixture of all colors of the spectrum. Filters change the appearance of light by eliminating some colors and enhancing others, in varying degrees. Because the quality of light determines much of an image's impact and influences our emotional response to it, filters are important tools that dramatically increase your creative control. Their optical quality is no less important than that of your prime lenses, so buy the best-quality filters you can afford and avoid the inexpensive ones sold in package deals by some camera retail stores.

Polarizing Filters

In general or non-macro photography, polarizing filters are used to remove reflections from nonmetallic materials, such as water and glass, and to darken skies to accentuate clouds. In close-up photography, polarizing filters are used to increase the apparent saturation of colors and to decrease contrast by eliminating specular reflections and highlights (small reflections from shiny or irregular surfaces). When shooting wet foliage and leaves, polarizers are used to remove reflection and glare and make colors appear richer. They are also invaluable when photographing the inhabitants of tidepools or when shooting through the glass walls of aquariums and terrariums.

There are two types of polarizing filters: circular and linear. The type you need depends on whether your camera uses a beam-splitting metering system. (Check your camera's instruction book or ask at a camera store.) Using the wrong kind of polarizer will cause inaccurate meter readings and lead to improper exposure.

With a polarizing filter, there is a loss of light between one-half and two and a half stops, depending on the degree of polarization. This is compensated for by your camera's meter. Polarization works best when the camera is oriented at a 90-degree angle from the sun. If the sun is directly in front of, behind, or above you, there will be minimal or no polarization effect.

Polarization need not be an all-or-nothing proposition. Specular highlights do exist in nature, and you may not wish to eliminate them completely from your picture. Adjust the degree of polarization to suit the images. Look through the viewfinder while turning the filter, and choose the most pleasing effect.

On some days, the light may be just a bit too bright and the contrast range too great for the film you have chosen. You can then use your polarizer as a neutral-density filter to remove up to two stops of light without changing your f-stop or shutter speed.

The best polarizers have a thin profile and are made from anodized brass, which has

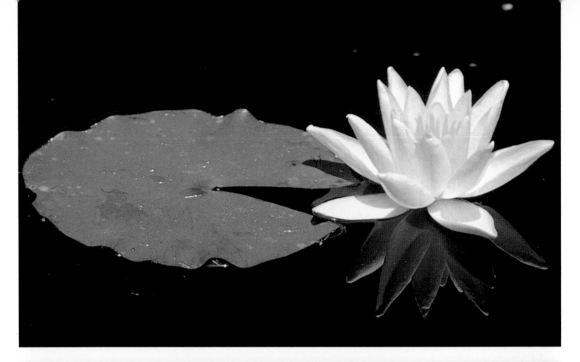

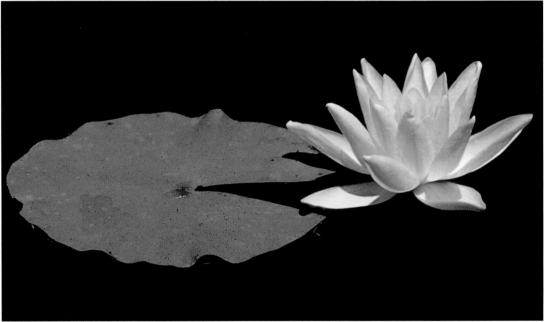

Water lily with and without polarizer. *The top image was taken without any filtration or manipulation. In the bottom image, a polarizing filter, set at full polarization, completely removed the reflection of the water lily. Notice how it also eliminated the specular highlight in the upper corner and darkened the water lily leaf. The decision whether to use a filter should be an esthetic one; neither representation is necessarily better. Both the image with the reflection and the image with the flower floating on a sea of black are legitimate expressions. Having a polarizer in your camera bag simply provides you with another creative option.* M. L.

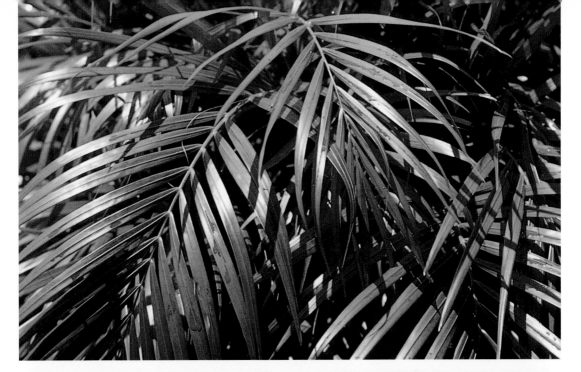

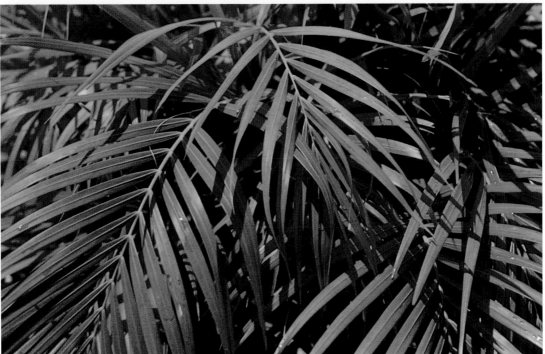

Foliage with polarizer. *By removing specular highlights, polarization increases color saturation. This can be an effective method of deepening the color of foliage, as demonstrated here with these palm fronds, which were wet after a late-afternoon rainstorm in Trinidad. If you don't wish to entirely remove the highlights, you can use the polarizer on partial strength.* M. L.

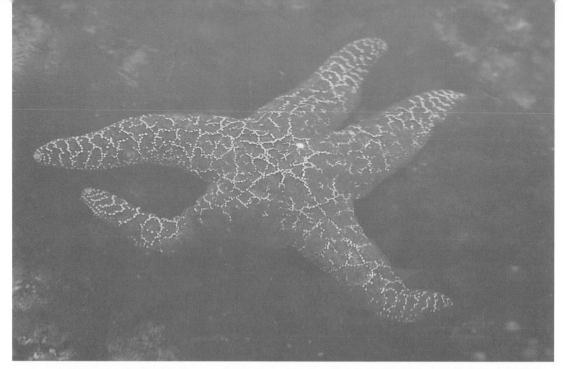

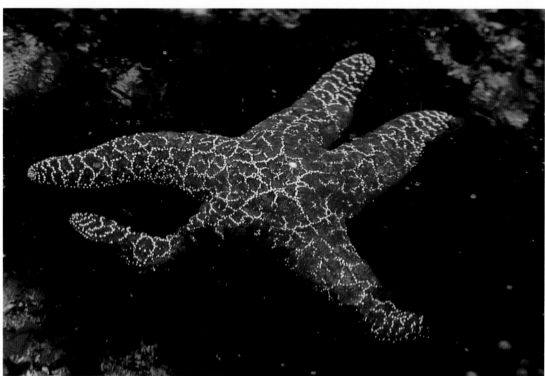

Starfish in tidepool. *This starfish was photographed in its home on the Oregon coast. A 200mm macro lens provided good magnification from the edge of a 10-foot tidepool, and a polarizer allowed me to penetrate beneath the surface.* M. L.

Mudflats in Zion. *A polarizing filter was used at approximately one-quarter strength for this shot in Zion National Park. The water remains semiopaque and forms a boundary and a balance for the mud ripples. Some continuity is maintained by the ripples faintly seen through the surface of the water. By using the polarizer at only partial strength, the colors are enhanced and the sheen on the mud is still preserved.* M. L.

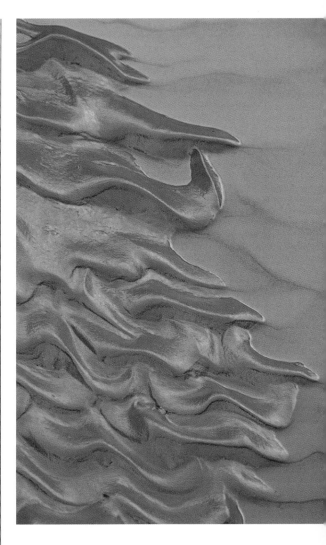

less of a tendency than aluminum to bind during operation. The thin profile helps prevent vignetting—the darkening or cutting off of corners—especially if you are using two or more filters or a wide-angle lens.

Warming Filters

Daylight color slide film is balanced to give its most accurate color rendition in midday sunlight. If you shoot in shade or in early morning, you may notice that the light tends to have a slightly cool, or bluish, cast. You can compensate for this color shift and restore a more natural-looking color balance by using the Wratten 81 series of filters (81A, 81B, 81C, from weakest to strongest) to absorb blue light in various degrees. This effectively exaggerates the warmer tones: red, orange, yellow, and brown. In autumn, using warming filters will enhance the colors of foliage close-ups.

Since many modern films are biased toward warmer hues, you must determine by trial and error which filters work best with which films. We use an 81B to warm up Kodachrome 64 and an 81A with Fujichrome Velvia or Ektachrome 100SW, films that have more color saturation and a tendency to enhance warmer colors.

Enhancing Filters

The rationale for using warming filters is to accentuate a color that is already present in the image but still maintain a reasonably natural appearance. The effects created by many of the enhancing filters, on the other hand, often appear too unrealistic and even garish, although the new Singh-Ray Color Intensifying enhancing filters are closer to neutral than most. To judge the results of these filters, look at the rendition of whites, blues, or grays; if you see a magenta or purplish cast, the filter is too strong.

Stacking Filters

On some occasions, a polarizer and a warming filter may be stacked together and used simultaneously. At times you may wish to

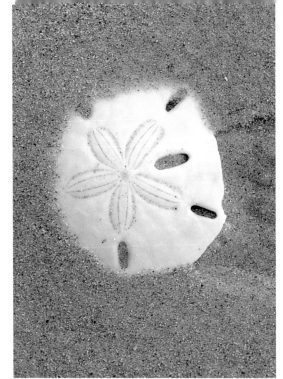

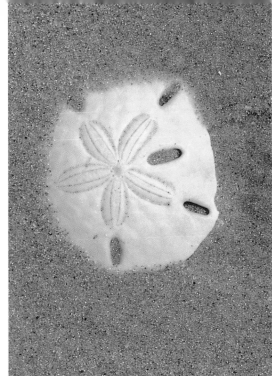

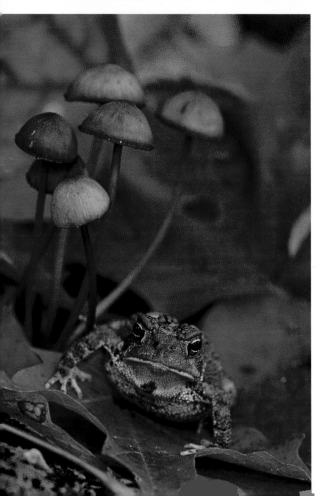

Above: Sand dollar. *The image on the left was taken with Ektachrome E100S, ISO 100, and exhibits a fairly neutral palette. For the second image, an 81A warming filter was added. Which is "better" is a matter of personal taste. If you leave your filter on all the time, you will not have the opportunity to make that esthetic judgment. Ektachrome E100SW is a fine film that will give you consistently warmer colors but also eliminates some of your artistic choices.* M. L.

Left: Toad and toadstools. *One of our favorite autumn haunts is the Adirondack State Park in northern New York. This eastern woodland toad was photographed with a 200mm lens and fill flash, using an aperture of f/16 to provide good depth of field without too much distraction from background and foreground. The toad was shot from eye level, not only to increase the impact of the image, but also to further eliminate some of the woodland floor detail. An 81A warming filter accentuated the autumn colors.* M. L.

accentuate the color while removing distracting specular highlights, such as when shooting autumn foliage after rain or fog. When stacking filters, it is important that both filters be clean and of the highest optical quality. Use your depth-of-field preview button, and watch for vignetting or flare.

Some photographers leave an 81A or 81B warming filter on the lens all the time, claiming that they like the warm tones it produces. We do not do this, because we feel that the use of any filter should be a calculated esthetic decision. The same applies to warming polarizers, which combine a polarizer with a warming filter. Although they certainly are convenient in some situations, it is not always best to have polarization with warmth.

Color-Compensating Filters

Color-compensating (CC) filters make specific corrections in color balance and are manufactured in varying intensities of blue, green, red, cyan, magenta, and yellow. They come in increments of .05, with .05 having the least effect and .30 the greatest. For most colors, a variation of .20 to .25 is just discernible to the eye. They may be glass,

Moth in autumn leaves. *After a cold autumn rain in Adirondack State Park, I photographed this seemingly dead moth that had been beaten down by the storm. After the photo session, I carefully removed the moth from the puddle and placed it on a rock, thinking to use it in a few moments on a different backdrop. The moth had other ideas, however, and after absorbing some heat from the sun, it fluttered away, apparently none the worse for wear. Autumn is a time of ending, but it is always followed by rebirth.* M. L.

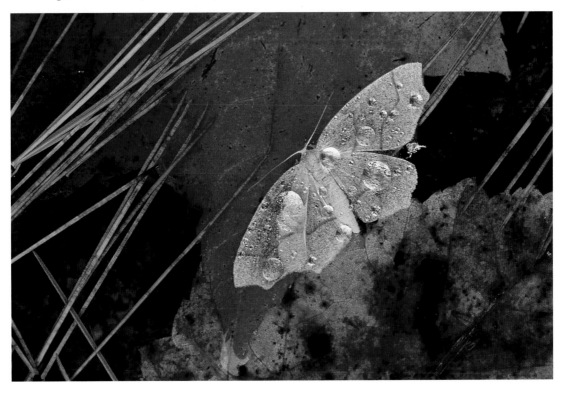

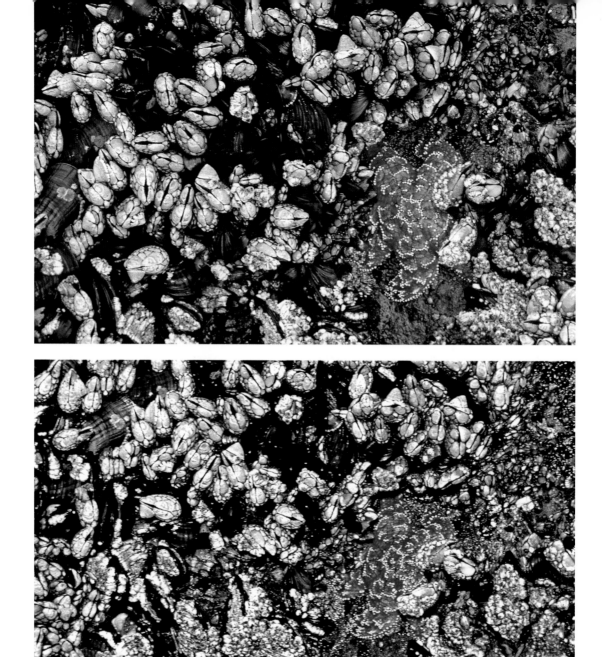

Starfish and barnacles. *A sea star, mussels, and several species of barnacles share living quarters on a seawall at Bandon, on the Oregon coast. The top image was shot on Fujichrome Velvia at ISO 40, without any filters. For the bottom image, I used an 81A warming filter stacked on a polarizer at approximately half strength. Good optical quality can be maintained if the filters are of the same excellent quality as the primary lens. Stopping down to f/8 also minimizes any curvature of field.* M. L.

screw-on filters or gelatin sheets that go in special holders in front of the lens. The gels are delicate and easily damaged, so treat them carefully and keep them dry. The advantage of gels over glass filters is that they are much lighter in weight, so you can carry a greater variety.

If you are shooting in a greenhouse or in a rain forest and would like to accentuate the greens without adding a greenish tint to everything else in the picture, try using a CC10G filter (color-compensating, .10, green). When photographing flowers in the midst of foliage, try the appropriate red, orange, or yellow CC filter in a .10 to .20 range to punch up the color of the flower without affecting the green of the surrounding foliage.

Film

Choosing Films

There are several important attributes to be aware of when evaluating films: sharpness and contrast, reciprocity, and color bias and saturation. Sharpness is a function of grain size, and slower films generally yield sharper images. This may be associated with increased contrast. Reciprocity refers to the relationship between shutter speeds and aperture, as described on page 2. This relationship begins to break down as exposures become longer than 1 second, resulting in underexposure or shifts in color (the image may become more magenta or more yellow). In such situations, many films require longer exposures than the meter indicates. Neutrality, or color bias, refers to the tendency of certain films to shift away from clean whites and neutral grays or to emphasize certain hues.

The best ongoing comparative film testing we've found appears in George Lepp's *The Natural Image.*

Nothing beats trial-and-error experimentation and firsthand experience. Take good notes. Settle on one slow, fine-grained film and one faster film for poor light or rapidly moving subjects. Once you've found the films that suit the majority of your shooting, stick with them. Going out into the field with half a dozen different films in your bag can lead to considerable confusion, especially if the ISO ratings are different.

We use Fujichrome Velvia for most of our wildflower work, where we feel that this film's supersaturation of colors is a benefit. When we want a more subdued or natural look, Ektachrome E100S is hard to beat. In the past, when we needed a faster film, we used Fujichrome Provia pushed to ISO 200. Recently, however, both Fuji and Kodak have introduced higher-speed (ISO 200 or greater) transparency films that deliver superb quality with little or no loss in sharpness.

Amateur vs. Professional Films

Amateur and professional films are essentially the same when they leave the factory. They both have a "peak" time, when their sensitivity to light and ability to faithfully record color are optimal. Professional films are packaged close to their peak aging time and are intended for immediate use, with refrigeration before and after exposure. Amateur films are released prior to their peak time, with the assumption that they will be on the shelf (or even in the camera) for a while and probably will not be processed immediately. We have used both amateur and professional versions of the same film and have not noticed any practical difference between the two. We do, however, take care to keep our film refrigerated, especially after exposure, because it is the latent image, exposed but unprocessed, that is most vulnerable to

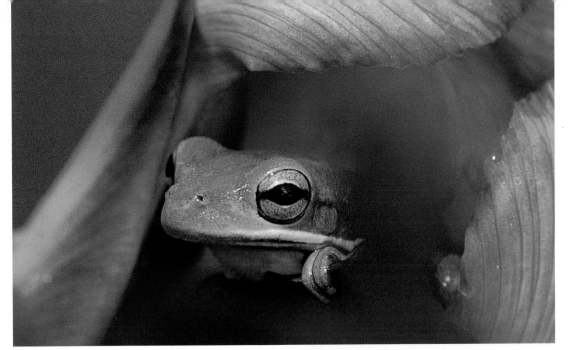

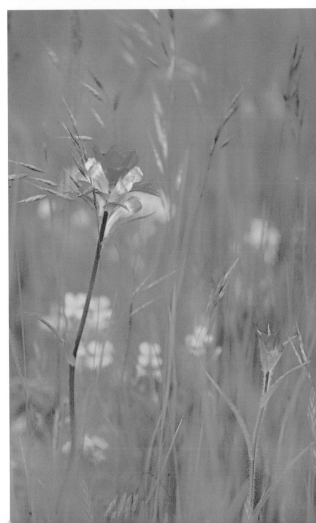

Green tree frog in blue flag iris. *During a close-up photography workshop on our farm, we persuaded this green tree frog to take up temporary residence in a blue flag iris. He felt quite safe and seemed totally unconcerned as several photographers immortalized him on film. This image was taken with fill flash, at an aperture of f/8, to eliminate unwanted detail in the background and foreground. Ektachrome E100S has a fairly neutral color palette and fine grain structure. When shooting amphibians in a set, keep them moist with an occasional fine mist from a spray bottle. Be alert for signs of stress—amphibians may hyperventilate when upset—and set a limit to shooting time.* M. L.

Texas paintbrush. *The Texas Hill Country was created with Velvia in mind (or maybe it was vice versa). No warming filter was necessary to achieve superb color saturation.* M. L.

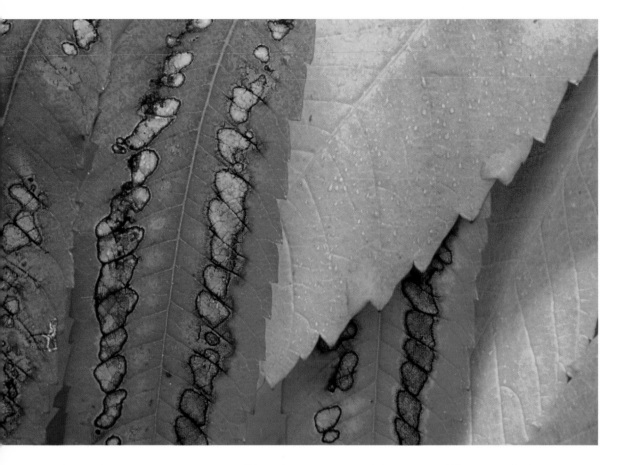

Above: Sumac leaves in autumn. *The color saturation of Fujichrome Velvia is such that a warming filter is often unneccesary.* N. R.

Right: Sunrise moth. *Dawn is a great time to shoot butterflies and moths. They are sluggish from the cold night air and will pose, unmoving, until the sun brings their body temperature up to at least 65 degrees F. If the night has been chilly and the humidity high, there can be an added bonus of dew. The subdued monochromatic colors and out-of-focus background enhance the subtle beauty of this image, shot in the Hill Country of southwest Texas on a spring wildflower hunt. Always be alert for serendipitous chance encounters. Some of the most stunning and enticing subjects may be found while you are looking for something else entirely. I used E100SW film and hand-held fill flash. No warming filter was needed.* M. L.

degradation. Try shooting both amateur and professional versions of the same film during one trip and compare the results. You can often save $2–$3 per roll using the "amateur" version of your favorite film, if there is one.

Film Processing

Because film is most vulnerable to image deterioration after exposure and before processing, it should be processed as soon as possible after exposure. Processing options

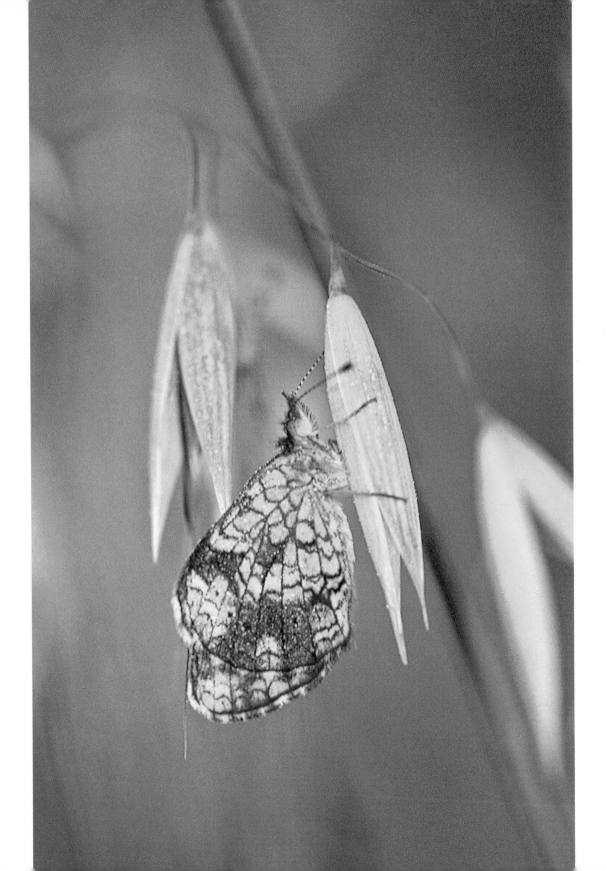

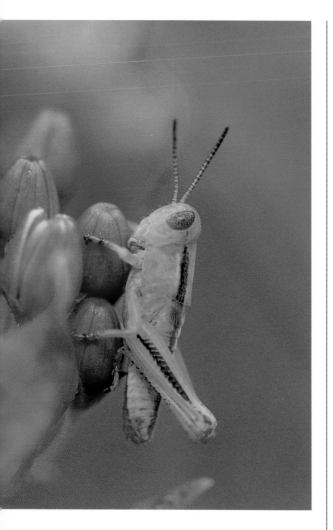

Grasshopper on butterflyweed. *The color saturation of Velvia is almost too much at times. A diffuser would have been helpful to dim the brightness in the upper left corner. A 200mm macro lens was used with a 5T close-up lens for greater than 1:1 magnification. Despite an almost 5-second exposure, there is no perceptible significant color shift.* M. L.

option. In addition, if you are a frequent customer, you can often negotiate a price for processing that may be almost as economical as mailers, if you consider the cost of shipping.

No matter who does your processing, insist on certain standards of cleanliness and care. Look for consistency from batch to batch. Watch for scratches, chemical stains, and fingerprints. Choose a lab that processes enough slide film to ensure that the processing chemicals are changed frequently. Most mall labs process mostly print film in C-41 chemistry and do little slide film. Quality control is often a problem with the processing done through discount stores and pharmacies.

Most slide films, except the Kodachromes, are processed by labs in E-6 chemistry. If you feel adventurous, ask your lab to process a roll of slide film in C-41 print film chemistry. (Be sure to tell the lab what kind of film it is.) The colors become psychedelic and totally unlike the original scene. This can be fun with shots of butterflies and flowers.

Traveling with Your Film

Airport X-ray machines are potentially hazardous to your film. Always have your film hand checked whenever possible. Plastic see-through containers make passing through airport security checkpoints simpler. We take our film out of the cardboard boxes and put the canisters into flat Rubbermaid containers that hold approximately thirty-six rolls of 35mm film.

include pharmacies and discount stores, photo or camera shops, and prepaid mailers.

The most economical way to process large quantities of film is by prepaid mailers. Mailers are available for less than $5 per roll from any of the larger retail camera stores. Send your exposed rolls with the correct number of mailers, instructions, and adequate postage for return.

Local processing, however, has some advantages over mailers. If you are in the learning stages and would like to discuss your newly returned slides with someone, a local photo or camera shop may be a better

Natural Light

Photographers often ask us for directions to the spots where we photographed images that they admired, wanting to repeat our experience. We willingly share that information, but we cannot guarantee the same light. Not unexpectedly, those photographers often return with negative reports if the light isn't happening. What is ordinarily a mundane image can become magical in special lighting conditions. Time of day and weather are two important factors.

Time of Day

In early morning, light is uniform and soft, creating low-contrast conditions that cause the important details of texture and pattern to stand out. The early-morning hours give a cool, bluish cast to your images, which may or may not suit your interpretation of the subject and of the moment that you are trying to portray. If you want your image to be warmer, or more neutral, use an 81 series warming filter.

In late afternoon, light is warm and colors appear more saturated. Flowers, creatures, details, and patterns all seem to radiate light from within when viewed in the glow of late-afternoon light. And close-ups of subjects bathed in the light of a sunset can be striking, reflecting an artistic rendition of the sunset.

Even after the sun goes down, there's often more light than you realize. One day in Valley of Fire State Park, Nevada, we thought our shooting was over for the day. Heading for the exit, we noticed that the sandstone formations called hoodoos remained aglow. Although we needed a flashlight to set up equipment, the rock patterns were still alive with light. A long exposure of several minutes, with the shutter set on "bulb," allowed for a successful image.

Weather

People often assume that images will look better when photographed in bright sunlight. But in actuality, some photographs will be more successful if shot in overcast light. Although subjects may look beautiful to the eye in the glow of bright sunshine, on the light table they may appear contrasty, with burnt-out highlights and detail.

Overcast skies, on the other hand, produce soft, low-contrast, diffused lighting that preserves details that might be washed out in full sunlight, often making it better for close-up photography. Without the bright highlights and dark shadows, it's easier to find middle tones to meter from and to determine exposures.

Rainy days also can be a boon to the close-up photographer. Not torrential downpours, of course, but gentle showers. Moisture will drizzle softness on flowers and leaves and paint tree trunks with black wetness. Your

Above: Sand pattern sunrise. *Beaches are great locations in early and late light. We arrived so early at this Port Aransas, Texas, beach that it was still dark and we needed flashlights to find our way. We had scouted the area the day before and knew exactly where we wanted to be. Our early awakening was rewarded with a magical sunrise. Once the sun had risen over the horizon, light danced through ripples in the sand and warm rays glowed on shells, puddles, and grasses. The golden glow and directional sidelighting provided another hour of early-morning photography. The specialness of the light made this area of sand magical. Viewed in midday sunlight, we probably wouldn't have given it a second glance.* N. R.

Above: Two shells. *The juxtaposition of these two shells attracted me. They almost looked as if they had been placed there, but there is a gradation of sand coloration that could only have happened naturally. I placed my camera back parallel to my subjects and used an aperture of f/22 to achieve maximum depth of field.* N. R.

Left: Shell and sand ripples. *To portray some of the intricate patterns and shapes found on the beach, I chose to work in early-morning light, as subtle details are often lost in brightness. Patterns begin to emerge when you explore your subject from different angles and perspectives. I spent some time crouching and changing my angle of view before coming up with this combination. The shell provides a point of reference.* N. R.

Right: Dragonfly on red berries. *The dragonfly's wings were still wet from heavy dew and would not allow the insect to fly. This gave me time to line my camera back parallel to its body. I didn't want too much of the background to be included in the image, so I chose an aperture of f/5.6.* N. R.

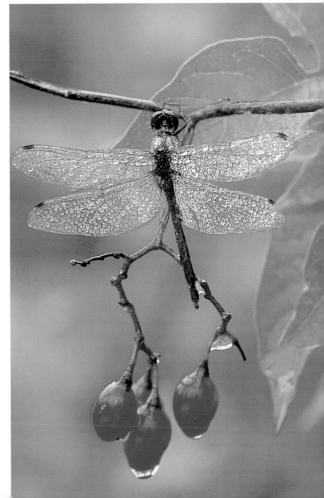

Top: Frosty primrose without warming filter. *One cold fall morning in Zion National Park, I came upon these primrose leaves lined with frost. On cool mornings, the light can often cause images to appear blue. As blue is a cool color, images photographed in that light have a cold feeling. Whenever I view this image, I remember how cold I felt that morning, and this suits my interpretation.* N. R.

Bottom: Frosty primrose with warming filter. *Wanting to experiment, I placed an 81A warming filter on the lens, and it changed not only the tone, but also the feeling. As I wasn't sure which interpretation would be more successful, I shot it both ways so that I could decide later on the light table. I still vacillate in my opinion about this image, preferring the warmer on some days and the cooler version on others. When using filters, photograph the subject with the filters on and off or bracket the amount of filtration. Sometimes a color shift or an unrealistic portrayal of a subject occurs with filters, which may not be what you had in mind. Even though I can pretty well anticipate results at this point, I like to have choices when I am reviewing the images on the light table.* N. R.

images will have fabulous color saturation, with an aura of mood and mystery.

With careful planning, photographing in the rain can be a gratifying, successful venture. Our rainy-day box contains the following items:

- rain boots, rain pants, and jacket
- brimmed hat
- golf umbrella, which doubles as a diffuser
- towels
- Ziploc bags and trash bags
- camera and lens raincoats (shower caps, homemade waterproof nylon covers, or housings sold by A. Laird or Pioneer Research)
- extra batteries
- lens shades

A word of caution when photographing in the rain: In moist conditions, our modern electronic cameras and the batteries they contain may fail. Extra batteries might alleviate the problem, but sometimes conditions are such that no amount of battery power will work. At the end of your shoot, open your camera back and let it dry out. You can dry your equipment with a hair dryer, but do not use high heat settings, as excessive heat may melt the plastic components.

Manipulating Natural Light

Photographic film does not always accurately record the beauty we see with our eyes. The difficulty lies in the problems surrounding contrast ranges, the ranges of dark and light tones in your photographs. A subject is said to have normal contrast when it contains middle tones (18 percent reflectance) and a full range of tonality from black to white. A low-contrast image has mostly middle tones and few very light or very dark values. A high-contrast image has few middle tones and has very light or very dark values.

Slide film can record only five stops of light, two and a half stops on either side of a middle tone; print film records seven stops of light, three and a half stops on either side of a middle tone. This is known as the latitude of the film and is the reason for the loss of shadow or highlight detail. If an image contains more than five or seven stops of light, it may be impossible for you to capture it successfully on film.

Meter from the darkest and lightest areas that contain important detail. If there is more than a five- or seven-stop difference, your subject is out of the recording range of your film, and you will experience exposure problems. In such cases, there are

Above: Maple leaf in reflection. *As the sun drifted lower in the sky and its last rays filtered through the autumn foliage, amazing colors began to occur in the Big Moose River in the Adirondacks of New York. I wanted to include an object within the abstract to provide a point of reference, so I waited until a leaf floated by. So that the surrounding colors and leaves would not interfere with the simplicity of the image, I isolated this one small section with a telephoto lens.* N. R.

Left: Reflection in stream. *The warmth of late-afternoon light adds a wonderful dimension to images. I came upon this stream as the reflection of the blue sky and golden maples was cascading in its waters. It was a moment of pure excitement, with calm occurring only after two or three rolls had been shot. I photographed the scene using both 35mm and medium formats, shooting vertically and horizontally, with and without rocks included, with long and short shutter speeds. Once I reviewed the pictures, I found that I preferred the effect of the longer exposure on the flow of colors, and the frames that included rocks. Whenever a scene excites you, experiment with both exposure and composition, and compare the results on the light table.* N. R.

57

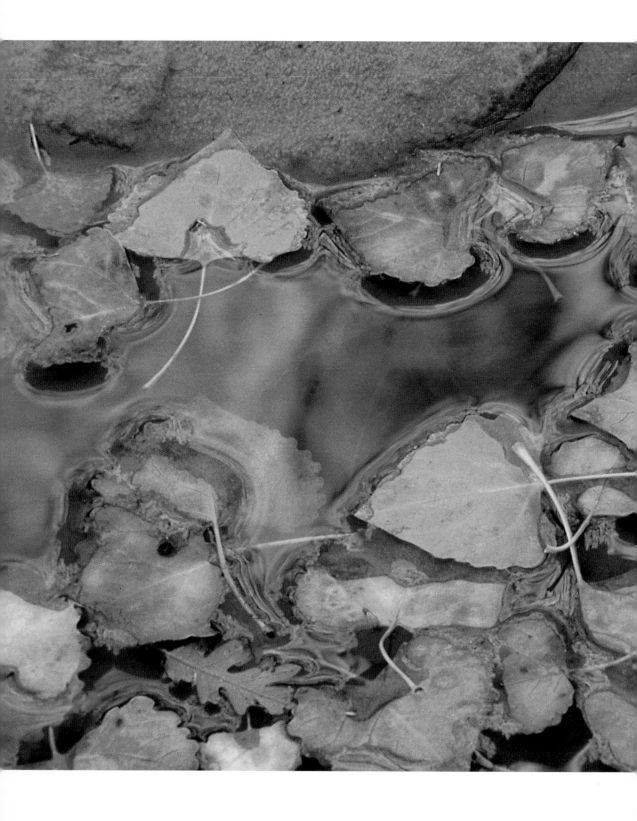

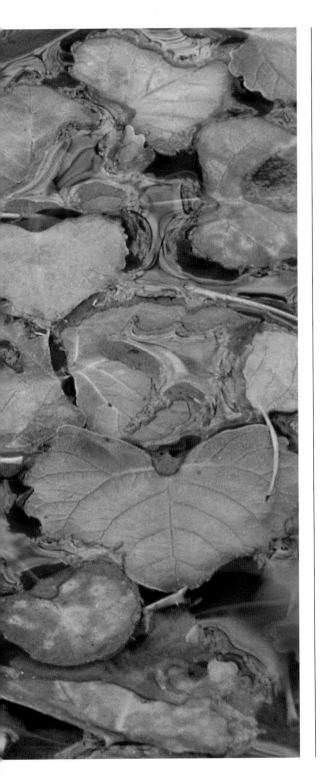

methods a close-up photographer can use to manipulate light that might save the day—and the image.

Diffusers

It would be wonderful if you could always be photographing in morning, evening, or overcast conditions. As a close-up photographer, you are often working in a small area, and you can create the effect of overcast skies by using a diffuser. A diffuser is a panel of some material, positioned between the sun and your subject, that scatters the light before it hits your subject. The density of the diffuser's material will control the amount of light that passes through.

Diffusers make it possible to take successful photographs on bright, sunny days. You can also use them on bright, overcast days—days that can sometimes fool you into thinking that there is no glare or contrast problem. Next time you are photographing on an overcast day, place the diffuser between your subject and the brightest part of the sky. You may be amazed at the amount of brightness that was hitting your subject.

You can make homemade diffusion panels with cheesecloth or silk-screen fabrics framed by cardboard or wood. You can also use a white umbrella. The easiest, most portable diffusers are those that are commercially made and fold up into a small, circular bag that fits neatly into a backpack or

Cottonwood leaves in reflection. *Our workshop group had been hiking in Zion National Park, Utah. It was shady as we walked between canyon walls, but sun was glowing on a sandstone rock face, casting a golden reflection into a puddle of cottonwood leaves. Ten tripods were soon huddling around this tiny body of water. Such moments in nature are what make photography so magical.* N. R.

Above: Anemone. *I had tried to photograph anemones on many occasions but was never really satisfied with the results. On this day, the skies were overcast, producing nice, soft light on my subject, and the anemones were in perfect condition. Wanting to capture as much detail as possible, I chose an aperture of f/16 or f/22. Because of the persistent wind, however, using a long exposure was a problem. Just as I was about to give up, the wind died down, and I was able to expose several frames. The overcast conditions saturated the color and lowered the contrast range, maintaining detail in the petals. Wait-ing for weather to cooperate is not always easy, but patience in close-up photography is essential.* N. R.

Left: Abalone shell. *The insides of shells contain mysterious designs. This abalone shell was iridescent in overcast light and became even more wonderful when enhanced with water droplets from my spray bottle. I filled the frame with the pattern, choosing to crop the peripheral lines of the shell.* N. R.

Right: Begonia. *This is probably the most photographed begonia in Pennsylvania. It was one of the greenhouse subjects at our spring workshop. It demonstrated not only the great patterns in flowers, but also how in overcast light these details just pop right out. A little "dew" from a spray bottle helped complete the picture. When photographing a subject such as this begonia, it is essential to place the back of your camera parallel to the subject to maximize depth of field. Because the begonia was photographed in so many different ways, we were able to compare various interpretations. Although some people photographed the entire flower, the more successful images were those that cropped the edges and concentrated on the center and surrounding design. Sometimes it's important to ask yourself, "What is attracting me to this subject?" That way you can isolate essential details. Remember that whatever doesn't add to your subject takes away from it.* N. R.

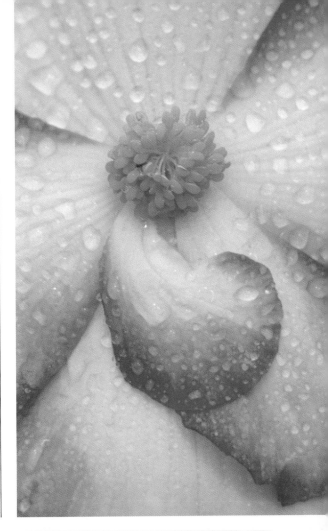

Below: Potpourri. *These walnut pods and petals had fallen on the ground after a rainstorm. The low-contrast situation created by the overcast light caused the details to pop and the colors to be saturated.* N. R.

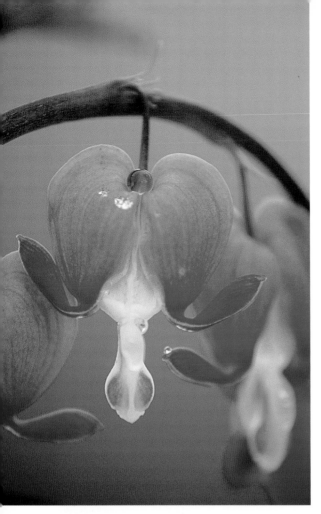

Left: Bleeding heart. *It had just rained, and the colors in our garden were wonderful. The waxy coating on a bleeding heart usually repels water, but there was one drop that managed to remain. The overcast sky provided soft, diffused conditions, and I used a large aperture to throw the background out of focus.* N. R.

Below: Woolly mullein in sunshine. *The bright sunshine causes much of the detail in this mullein to be lost.* N. R.

Top right: Woolly mullein diffused. *By holding a diffuser between the sun and the mullein, there is less contrast and more detail.* N. R.

Bottom right: Woolly mullein diffused and reflected. *A diffuser was used to create an overcast condition, and a gold reflector was incorporated to "kick in" some light. Make sure that neither the diffuser nor reflector screen is included in your image. This is easily accomplished if your camera is equipped with a depth-of-field preview button.* N. R.

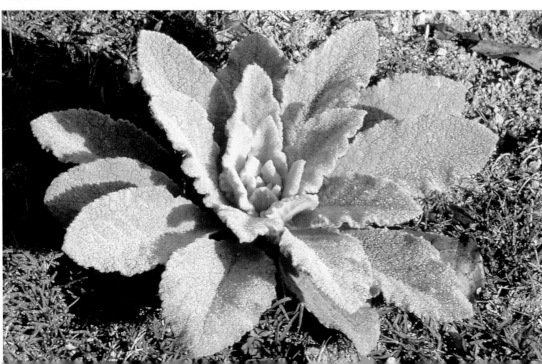

camera bag. They are not expensive and last for years.

Reflectors

Close-up photographers often seek out subjects that are found in small crevices or dark forests. Reflectors are wonderful tools that redirect natural light onto your subject.

They elevate middle-tone areas and open up shadows. With backlit subjects, reflected light can bring out details that would have been lost in a silhouetted image. Reflectors have an advantage over flash in that you can see the influence of the additional light through your viewfinder and can then make any necessary changes to the light before making the exposure.

Mirrors or crumpled aluminum on cardboard can be used as reflectors, but the best are the fold-up commercial reflectors that fit neatly into a pack. They are sold in gold, silver, and white. The gold produces warm tones, enhancing earth tones such as red, orange, and brown. The silver and white are more neutral and are useful as supplements to available light.

When using reflectors or diffusers, be careful to keep the edges of their panels out of your frame. Examine the edges and use your depth-of-field preview button to check for any obtrusions.

As with every piece of equipment, reflectors or diffusers are not for every situation. Soft light or interesting backlighting may add impact to your image. Experience will help you with this. Practice photographing subjects with and without the screens, and learn what each one can do.

Flash

When photographing small subjects, you must be fairly close in order to capture the image on film at a reasonable size. As you move closer to increase magnification, you are faced not only with decreased depth of field, but also with an effective loss of light with the addition of any extension device. Achieving a life-size magnification requires two additional stops of light to maintain correct exposure. Your camera's through-the-lens meter will automatically compensate for this light loss, but it does so by recommending (or setting automatically, if you are using a program or automatic mode) either a larger aperture or a slower shutter speed.

How, then, can you obtain enough light for correct exposure while still using a sufficiently small f-stop to provide adequate depth of field, as well as having some means of freezing motion? The camera and lens by themselves cannot satisfy all of these needs simultaneously. If you use a larger aperture to allow more light, the depth of field decreases. If you use a slower shutter speed, your final images may be blurred due to subject or photographer movement. The solution is electronic flash, which will provide adequate light for correct exposure while at the same time allowing you to increase depth of field and freeze motion. Having said this, we prefer to use

natural light at every opportunity, using flash only when we perceive a particular need for it.

Using a through-the-lens (TTL) flash unit is the best way to supply additional light when there is not enough light. Through its electronic connections with the camera, the TTL flash unit reads the light reflected off the subject by using the camera's sensor. Although more expensive than other types of flash, TTL units are an almost foolproof and hassle-free source of lighting for close-up photography.

As a primary light source, flash has certain limitations that have to do with its effects on texture and on the background and foreground. Texture is visible surface detail, consisting of combinations of shadows, highlights, and variations of hue. It can appear hard, like the ridges in a scallop shell, or soft, like the velvety patterns in rabbit fur. Textures are most visible at a middle or medium tonality, gradually becoming less visible at lighter or darker values. A single light source, such as an electronic flash, close to a small subject and pointed directly at it destroys texture and detail by eliminating the shadows and highlights, washes out color, and can create harsh shadows behind or alongside the subject.

Twenty years ago, you could always tell when a photograph was taken using elec-

Hummingbird moth. *Full power flash was used to freeze the motion of the rapidly moving wings as this hummingbird moth hovered over a teasel. At an aperture of f/22, the depth of field was adequate, and most of the background was close enough to the subject to avoid the "black background syndrome." A bit farther back, however, the background has gone black where there was no object close enough to reflect light. The flash was angled in from the upper left to avoid washing out the moth's furry texture.* M. L.

tronic flash as the main source of light. The effect was harsh, and shadows and texture were obliterated, but most objectionable were the black backgrounds, which turned many people off to the technique entirely. These black backgrounds so common in early full-flash images are simply the result of the inverse square law, which states that the intensity of light decreases in an inverse proportion to the square of the total distance it travels.

From any individual light source, light radiates equally in all directions, so the light energy disperses in a predictable manner as the light travels farther from the source. If, for example, the light-source-to-subject distance is doubled, the light falling upon the subject is only one-fourth as strong as it was originally. Conversely, if the subject is moved closer to the light source, the light falling upon it is more intense. You don't need to remember the particulars, but having at least an intuitive grasp of the principles involved is helpful, especially when dealing with backgrounds and foregrounds.

Let's say that your subject is 8 inches from the light source. By the time the light from the flash has traveled 8 inches behind the subject, it is one stop less intense. Therefore, if there is an object 8 inches behind the subject, it will be one stop underexposed by the flash. This would be perfect for a background; it would be one stop darker than the subject and that much less intrusive. This also explains why an object 8 inches in front of the subject would be one stop overexposed and quite distracting. By the time the light travels 16 inches behind the subject, it has lost two stops of intensity, and two stops darker than middle tone is practically black.

If you wish to have any visible detail in the background, it must therefore be fairly close to the subject. A black background can be avoided by moving subject or background so that the background is closer to

the subject. You can also move the flash farther away, so that the distance between subject and background is decreased relative to the position of the light source. The problem with that solution is that there will be less light falling upon the subject. You can solve this by lighting the background separately with either a reflector or a second flash. You may also base your overall exposure on available light values and use the flash to fill in areas of shadow.

Achieving Balanced Lighting

Modern, multifunction, dedicated TTL flash units are wonderful tools that can be used to ensure adequate lighting in almost any situation. These camera-and-flash systems can compute and then supply just enough light to create a perfect exposure, balancing daylight and flash. With some trial-and-error testing, following the steps outlined below will allow you to produce perfectly exposed flash close-up photographs, with balanced light and little pain.

1. Set the camera exposure mode to manual or aperture priority. (For evaluative or matrix metering systems, see your owner's manual.)

2. Choose the type of metering pattern you'd like to use. Spot metering allows the greatest degree of control, but center and bottom-weighted averaging systems give good results as well.

3. Set the aperture on your lens according to the depth of field desired. If you want as much depth of field as possible, set the aperture to f/16 or f/22. For a more impressionistic rendition, you can use a wider aperture. Watch your background.

4. Set the shutter speed for the correct available-light exposure. This allows the flash to fill in with just enough light to finish off the correct exposure without burning out the highlights. On bright, sunny days, you can get ghost images if you use too slow a shutter speed.

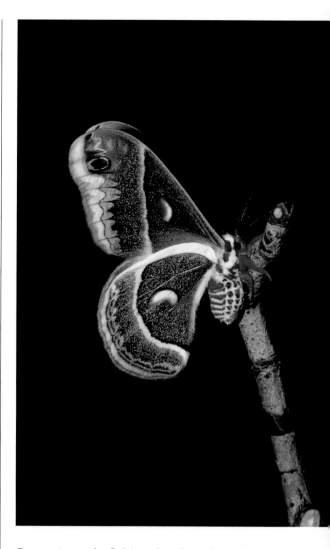

Cecropia moth. *Subject details such as dark or black spider legs, antennae, and edges of butterfly wings disappear into black backgrounds. To use electronic flash effectively, you must use it not only as a primary light source, but also as fill light, to supplement natural light without overpowering it. This cecropia moth was shot with full flash at f/16 and was published in the 1980 Sierra Club Engagement Calendar. It's an excellent example of the "black background syndrome." An image like this likely would not be accepted for publication today.* M. L.

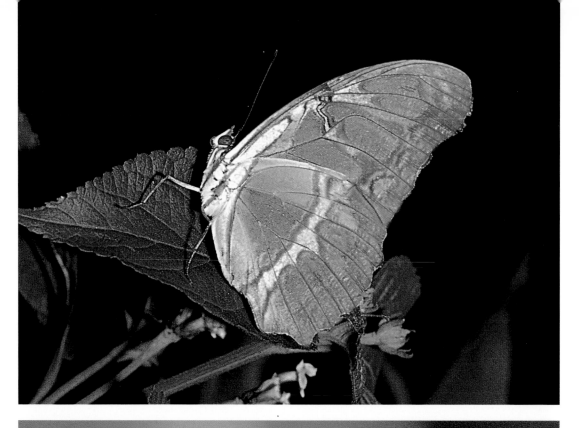
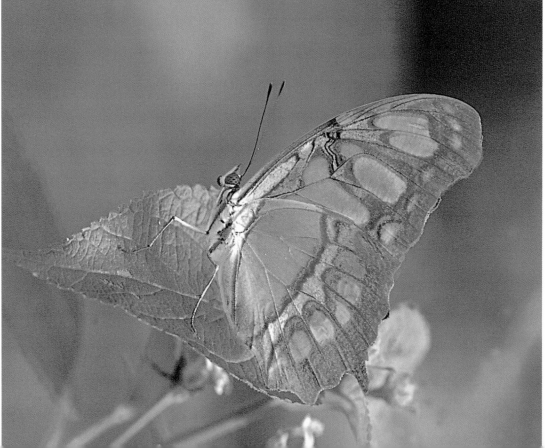

Above: Six-spotted fishing spider *(Dolomedes triton). Fishing spiders live on and near ponds and slow-moving streams. They are not aquatic, as are the diving spiders, but they prey upon small fish and tadpoles, as well as insects that live around water. The convection currents from my waders caused continuous waves, so full flash was used to freeze motion. The spider was fairly close to its background, so there was not enough light fall-off to cause the background to go black, but note the telltale shadows under the legs. This image was taken at a private hunting preserve near Clewiston, Florida, just south of Lake Okeechobee.* M. L.

Left: Butterfly, full and fill flash. *These two images, shot at the Butterfly Farm in La Guacima, just outside San Jose, Costa Rica, demonstrate clearly the advantage of fill flash over full flash. In the top image, light fall-off has caused the background to turn black. The light on the butterfly is harsh and glaring, and its antennae and legs disappear into the blackness. The bottom image shows the advantage of fill flash. The overall exposure is based on available light, and the flash just adds snap to the details.* M. L.

This technique works only when you use the manual setting on your camera. With any of the program settings, such as aperture priority, the camera will automatically compensate for slower shutter speeds by readjusting the aperture, whether you want it to or not, making it necessary to use the compensation dials on the camera.

5. Set the zoom control on the flash. This adjusts the angle of dispersion of the light—the wider the setting, the wider the light dispersion. It controls a moving fresnel lens (a lens engraved with circular lines to diffuse and scatter light beams) within the flash head that focuses and concentrates the beam of light. At the wider settings

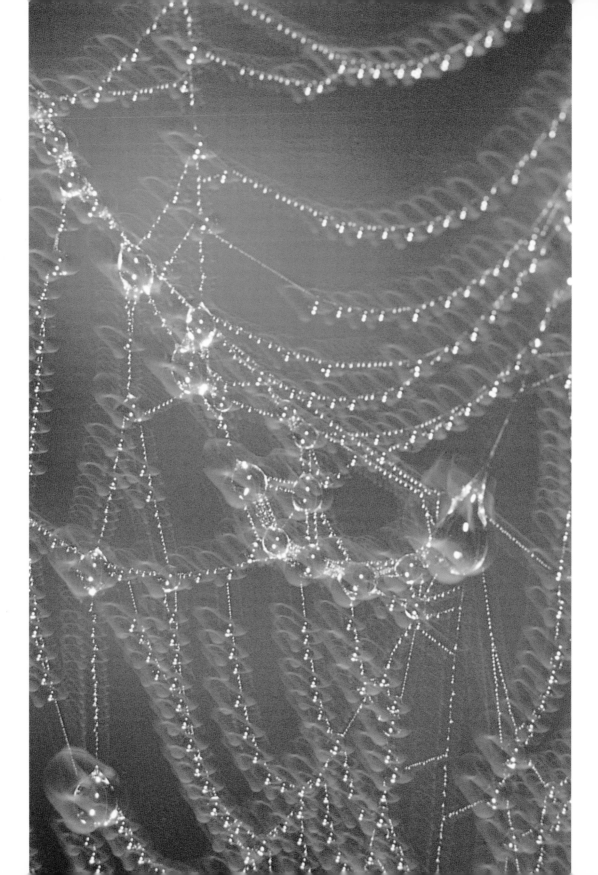

Above: Backlit argiope. *If full power flash had been used to illuminate this backlit banded argiope, the effect of the backlighting would have been lost, and in fact, the background would be completely black, since there is nothing behind to reflect light. I took a meter reading from medium-toned foliage and used fill flash to illuminate the spider. The fill was set to −2, so that the shadowed argiope would be lit but the delicate web and dewdrops would not be burned out.* M. L.

Left: Web in wind. *A slow shutter speed of 1/15 second was used with fill flash to capture a double image of this web. The slow shutter speed showed the movement of the wind-blown web, with the fill flash freezing motion at one point. The aperture was set to allow a normal available-light exposure so that the background would not go black.* M. L.

(28 to 50mm), the beam is more dispersed and covers a wider angle. As a consequence, it is also less powerful. At the longer settings (60 to 85mm), the angle of flash coverage is narrower, but the intensity of light delivered is greater.

For close-up photography, a wide-angle setting (28 to 50mm) provides more diffused lighting by covering a larger area. This setting need not be the widest available. As long as it is wider than the focal length of the lens being used, you will cover the field and achieve a diffuse flash effect without dark corners. If you set the flash to an 85mm setting and use a wider-angle lens, such as a 60mm macro, you will get light fall-off and dark corners. With a 100 or 200mm macro lens, however, even the 85mm telephoto setting is wider than the coverage of the lens, and you will obtain maximum power with no corner darkness. If you use a 60mm macro, make sure that the zoom setting on the flash head is 50mm or less.

6. Set the f-stop on the flash unit to correspond to the aperture chosen for the lens. (Some units do this automatically.)

7. Set the exposure compensation on the flash to -1 to $-1^1/_2$ stops for most subjects. This tells the flash not to fire at full power and determines the amount of fill light. The light from the flash should not overpower the natural light.

Flash brackets. *In the upper photo, Nancy's camera is tripod mounted, and her flash is supported on a bracket designed and manufactured by Bryan Geyer of Really Right Stuff. In the lower image, Michael is shooting hand-held, with arms tucked into the body for support. The flash bracket is from Kirk Enterprises. We customize our brackets with a small ball head under the flash and enough extension to remove the flash from the lens axis.*

Shoot at least one test roll. Most flash units warn you by blinking if the flash does not supply enough light and the image is underexposed. They do not warn you if there is too much light, however, and you may not be aware of overexposure until your slides return from the lab.

You can fine-tune your exposure using the compensation dials on your equipment. With predominantly light or dark subjects, use the camera's compensation dial as you would normally. Use the compensation controls on the flash to adjust the amount of fill lighting.

Hand-Held Flash

In close-up photography, it's best to shoot from a tripod when you can, but there are situations where this is simply not possible. If you're following hermit crabs through mangrove swamps or chasing zebra butterflies, a tripod may be more of a hindrance than an aid. And there are also locations where tripods and monopods are simply not permitted, such as some public conservatories, butterfly houses, and botanical gardens. In all of these situations, good hand-held flash technique is vital.

You need not sacrifice all stability just because you are not able to use your tripod. Custom flash brackets, such as those available from Really Right Stuff and Kirk Enterprises, are specifically engineered for the close-up photographer. These brackets adjust quickly, maintain a reasonable distance between the flash and the lens, and allow movement of the flash around the lens axis so that you can achieve directionality of lighting. It is the flash-to-subject distance that determines the exposure, not the location of the light relative to the subject. Think of your flash as a portable sun, and try to previsualize where the shadows will fall. You can even use a small, portable flashlight to help you accomplish this, if your subject is inanimate or very tolerant.

The secret of successful hand-held macro flash is to preset the magnification on the lens according to the size of your subject. Then preset the aperture according to the desired depth of field, and the shutter speed according to the amount of ambient light exposure required for balanced lighting. When you identify your subject, begin to focus by moving your upper body back and forth while bracing your arms. This

Ladybug on spiderwort. *Vignetting was used to provide a softer image of this ladybug on prairie spiderwort. A 200mm macro enabled me to maintain good working distance. The spiderwort was in the midst of grasses that prevented the use of a tripod, so I used hand-held fill flash on extension, taking care that the vignetting grasses were not struck by light from the flash.* M. L.

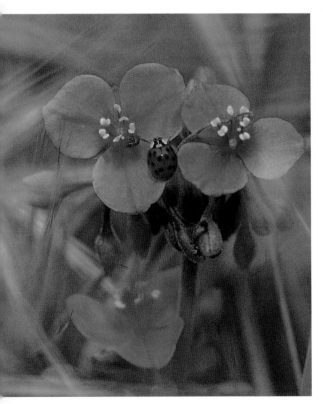

way you can keep a two-handed grip on the camera and lens, thus increasing the stability of the entire system. If you use one hand to focus, you are supporting the entire 3- or 4-pound unit with only one hand. Stability is critical for sharper pictures.

Modification of Electronic Flash

Electronic flash can be harsh and cold when used alone as a single light source, producing distinct shadows and highlights that are not always esthetically pleasing. There are several ways you can modify the light. Colored gels can be placed over the flash tube to add warmth, or to change the color balance completely, or for psychedelic special effects. Results can be determined only by experimentation. The light output can be decreased by using these gels or by placing a white handkerchief over the flash head, with two folds providing a decrease of about one f-stop.

Light from electronic flash can also be softened by the use of diffusion devices such as the Lumiquest ProMax Softbox, which causes a decrease of one to one and a half stops, or the Lumiquest Ultrasoft, which causes a two-stop decrease. These and similar devices are essentially large, translucent filters that are attached in front of the flash tube and make the light source more diffuse and larger than the subject. The larger the light source in relation to the subject, the softer the illumination. When the subject is already smaller than the flash head, the effect may seem fairly minimal, but when the diffusion chamber or screen makes the light source significantly larger than the subject, the result is more noticeable. These devices are most useful with white or highly reflective subjects.

Multiple Flash Technique

A balanced lighting effect can also be created through the use of multiple flash units. This technique increases the amount of

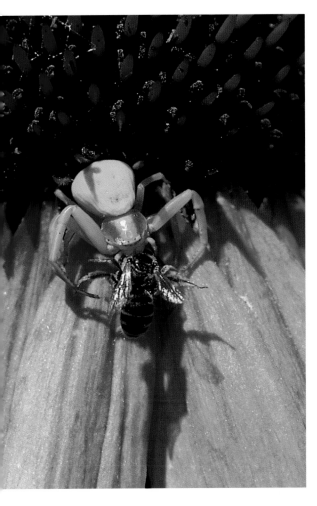
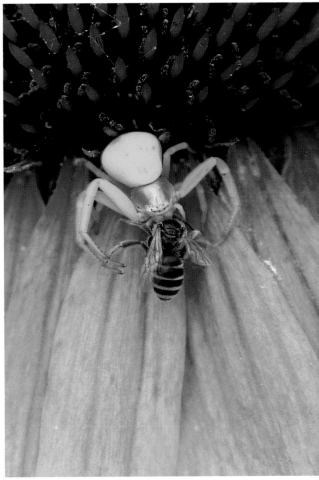

Crab spider with prey. *The left image was taken in direct midday sunlight. The lighting is harsh and glaring, with sharp, distracting shadows, and the black body parts of the bee merge with the shadows. The photo on the right was taken with a Lumiquest Ultrasoft over the flash. Exposure was set at the meter's recommendations, with fill flash at –1. The light is now softened and almost shadowless. You can manipulate the light from through-the-lens flash in numerous ways and still be reasonably sure that it will provide the correct exposure.* M. L.

light available, making it possible to shoot at very small apertures even with relatively low-powered units. You can manipulate the light balance and change the ratio of light falling upon subject, foreground, and background. There are drawbacks to multiple flash, however, including multiple shadows where they shouldn't be, multiple catchlights and highlights, and the unwieldiness of lugging 10 pounds of flash units, brackets, and connecting cords in the field.

You can simplify the situation somewhat by using a slave flash, a supplementary flash connected to an electric device that

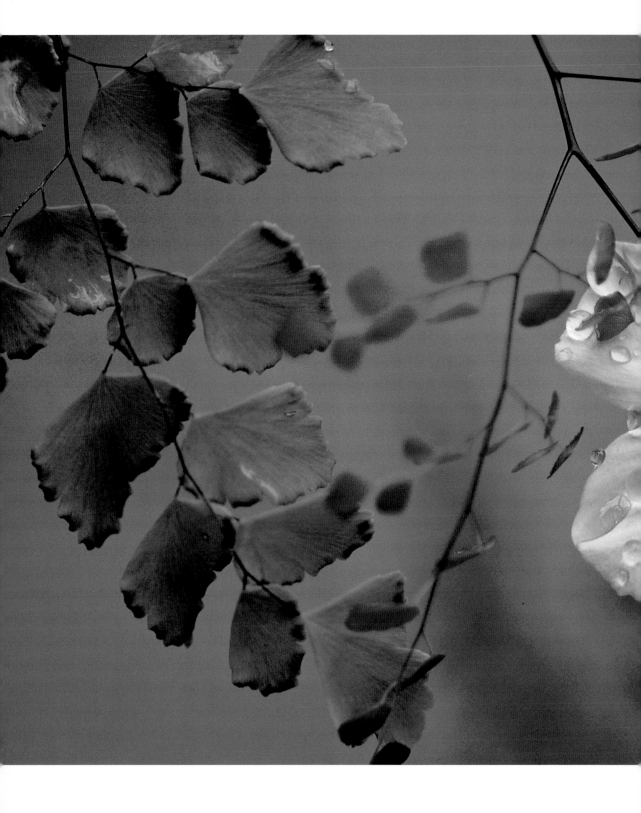

After the storm, Trinidad. *Fill flash, when used carefully, can add a little sparkle to even the most delicate images without losing the feeling of softness.* M. L.

contains a light sensor. When this sensor reads a burst of light from your primary flash, it fires the attached supplementary flash. There are no intervening cables, making setup and field use somewhat easier. Check out the new slave unit by Ikelite.

When positioning your flash unit(s), remember that the closer the light to the camera-and-lens axis, the less textural detail will be preserved. Light coming from straight ahead washes out detail by eliminating shadows, whereas light coming in from the side will emphasize texture. If your subject is fuzzy, furry, scaled, or otherwise covered with wonderful texture, make sure that at least one of your lights is directed in from an angle. That way, you won't lose the shadow detail that makes that texture visible in your photographs.

You can often achieve a multiple flash effect by using a small reflector or mirror instead of a second flash to kick back some of the light onto the subject. Manipulation of available light for background and foreground illumination with reflectors and diffusers is much less complicated than trying to arrange several external light sources in the field.

Esthetics

Poetry and Hums aren't things which you get, they're things which get you. And all you can do is to go where they can find you.
—A. A. Milne

You may have all kinds of wonderful camera equipment, and you may have learned all the proper techniques, but when you look at your images on the light table, you still may be disappointed. Just as the development of your technical skills did not happen overnight, the development of your photographic vision also takes practice, patience, and perseverance. By incorporating esthetics into the photographic process, you will move from reporter to interpreter and learn to express awareness and emotion in your images.

It is not an easy task to develop a photographic style that exhibits both science and poetry. Poetry enters photographs by way of the creative soul but is facilitated by technique. For so many of us, creativity is a tool that we don't often use in our everyday adult lives. In the Western Hemisphere, our emphasis on logic keeps us behind a wall of linear thinking and safe sensibilities. We need to get in touch with the artist side of our brains, which allows us to think in free and metaphoric associations.

Eliot Porter, master of detail in the natural world, said that a true work of art is "the creation of love; love for the subject first and for the medium second." Our goal should be to achieve a kind of intimacy in our images; to provide information about and convey our love for our subjects, so that they will become known to our viewers.

"Every child is an artist," said Pablo Picasso. "The problem is how to remain an artist once he grows up." A child's brain thinks in terms of magic and mystery, not mastery and manipulation. To obtain successful images, we have to get in touch with that child inside, and leave known territory for the discovery of new lands.

Awareness

Many photographers today seem to have a "fast-food" mentality. The photographer sees an image, grabs a camera, and snaps a couple pictures. The camera and tripod are tossed in the back of the car, and it's off to the next item on the menu. At the end of the day, eight rolls may have been shot, but

Poppy ballerina. *This poppy had reached the end of its time, but there was still beauty in its dance. I took its portrait, wanting to do more than simply document its existence. Going beyond a record shot requires you to reach into your creative self and abandon preconceived notions of your subjects.* N. R.

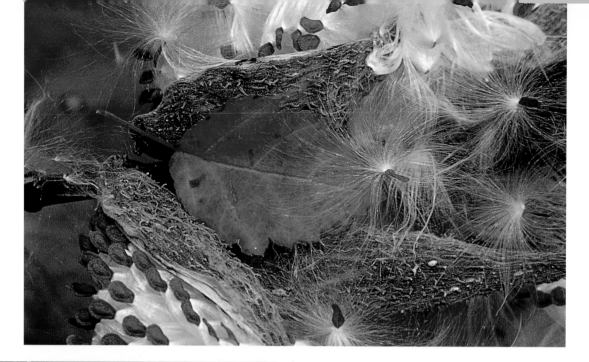

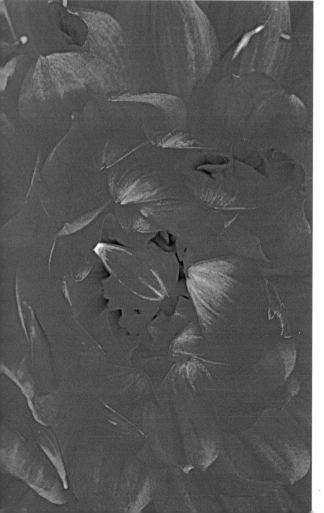

Above: Autumn leaf in milkweed. *Hillsides of sweeping hues, grand landscapes of oranges and reds, and lakes surrounded by kaleidoscopes of color make it easy to be caught up in the grandeur of it all. But small details, such as this combination of leaf and milkweed pod, can quietly represent this incredible season. You don't need to show the big tree that the leaf fell from or the whole milkweed plant.* N. R.

Left: Dahlia with petals. *Dahlias seem to grow larger in Oregon. The incredible red color of this one, combined with magenta petals from another, caught my attention. Red and magenta are two colors that one usually wouldn't choose to combine, but I think that's what I particularly liked about it. Your decision to photograph something should be based only on passion for the subject, and not on preconceptions and rules.* N. R.

what about the quality of those pictures? What about capturing the essence of a subject because you took the time to know it and understand it? As Gandhi said, "There is more to life than increasing its speed."

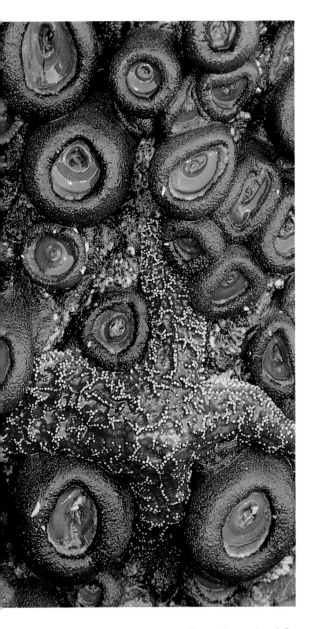
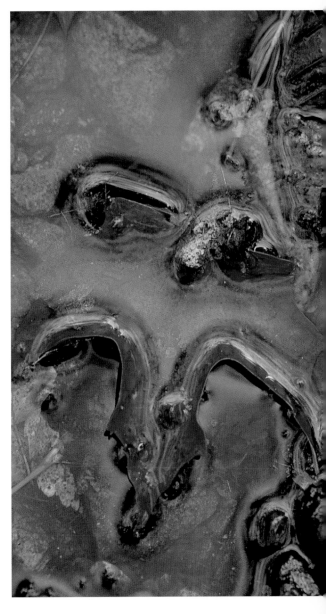

Above left: Sea anemone. *The tidepools of Oregon contain hundreds of potential images for the close-up photographer. A trip to the tidepool areas will reveal nothing, though, if the tide is in. Consult the tide charts before you plan a trip.* N. R.

Above right: Autumn leaf in reflection. *I drove by this stream on the way to another destination. Many of the trees along the bank were still green and cast a strange, green glow in the water. I noted the time at which I saw the reflection and returned the next day, when I searched for a subject to place into the water.* N. R.

Pause from your reading and indulge in a little experiment. Take one raisin or one M&M. Place it into your mouth. Close your eyes. Chew slowly, but don't swallow. Become aware of its taste and texture, and think about the characteristics particular to that raisin or chocolate. You can never really *know* a raisin or a piece of chocolate until you are willing to take the time to concentrate and focus on its inherent qualities.

The same thing holds true in photography. Spending focused hours in one small area of the yard, you can learn about a blade of grass, a crab spider on a daisy, patterns in the earth, and the tiny hairs on a flower's stem that glisten when backlit by sunshine. You discover their qualities while lying on the ground, peering behind them, and then from a standing position. Each vantage point adds a new dimension to the character of the subject, thus increasing your understanding of its personality and its relationship in nature. It is only by taking the time to really get to know your subjects that you can hope to go beyond simple documentation and capture the true essence of your subjects.

There is an inner eye that lies within us all. Sometimes it lies dormant, like a muscle

Cicada wings. *These cicada wings were left abandoned on some autumn leaves. Struck by the story they told of the passing of seasons and lives, I found the wings an even more interesting image than the actual cicada might have been. The fine details of the wings and leaves were wonderfully displayed in the perfect overcast light of the forest. Using symbols in your photographs is an effective method of telling a story. Viewers are encouraged to think about the events that took place surrounding the image and thus become involved in the story.* N. R.

Praying mantis. *Over summers of observation, we learned that one area of our field attracts a large population of praying mantids. An early-morning visit to that area gifted us with a mantis that had just shed its skin. Was it serendipity or preparation?* N. R.

that hasn't been used or a language that hasn't been spoken for a long time. With practice, your inner eye will start to work again, enabling you to see worlds that you forgot, or didn't know existed.

Using that inner eye, you feel the curves of petal potpourri scattered on mossy green and the tenacity of a dewdrop clinging to a blade of grass. You respond to abandoned cicada wings left to decay on a fallen leaf and to the pirouette of an oak spinner. When you tap into your inner vision, you begin your travel beyond personal horizons and start to feel a connectedness with nature and become aware of its rhythms.

To strengthen that inner vision, so that you can see in a deeper, more conscious way, start by merely slowing down. Before you begin a walk in search of images, take a deep breath. Look around you and focus on the ground below you and the sky above you. Smell the air and think about the flowers and grasses that grow from the earth upon which you are walking. Think of everything that might have happened where you now stand. Then refocus on where you are and the gifts that the day is bringing you. Inhale the nature around you and take nourishment from "the tonic of wildness," as Thoreau called it. This is a holistic process, through which everything is understood to

Skipper in bluebonnets. *Every April the Texas Hill Country becomes a photographic treasure chest. This patch of bluebonnets was filled with butterflies that were busily gathering nectar in the bright sunshine and were too active to be captured on film. We wrote down the location and returned early the next morning. Still wet from the evening dew, this skipper made a cooperative subject.* N.R.

Snail family. *Most living creatures follow a routine. By observing that routine, you are better equipped to capture them on film. I would not have obtained this snail image in duckweed if I hadn't spent the time observing them before taking out my camera equipment.* N.R.

Wind dance. *The wind was really frustrating me one afternoon. Had the subject not been so compelling, I would have packed up my gear. The light was low, and with an ISO 50 film in the camera, the image would not be sharp. I decided to photograph using the wind instead of fighting it. Choosing a long exposure, I allowed the wind to carry my subject in a free-flowing manner.* N. R.

Foxtail barley grass. *In a ditch down the road from our farm, these wonderfully colorful grasses appear at the end of summer. I watched them for years, never stopping to photograph, as I thought that with their constant movement, they would be too difficult to capture. But it was the flowing of greens and reds that attracted me, so they didn't really need to be still. Composing to fill the frame, I used a macro lens and a long exposure and let the blades wave in the breezes, creating a story about color and movement.* N. R.

affect everything else. You, as the observer, and your subjects, as objects, are both involved in the harmony and are transformed by becoming part of one esthetic experience. If your thoughts move along this path, your inner eye will soon develop, giving you a keen sense of awareness. Be open, awake, and patient. Your images will come to you as your inner vision becomes more acute.

Left: Cactus blossom. *Often the first photograph you take of a subject is not the one that you like the best or that best portrays how you feel about your subject. The first photograph is like an introduction to a person. After the initial handshake, you need to spend some time getting acquainted. My first photograph of this cactus blossom was to document it in a literal fashion— straight on and up close. As I examined the flower, I was struck by the delicate beauty supported by its thorny cactus stem.* N. R.

Below: Cactus blossom. *Although the first photo is appealing, the second evokes more emotion.* N. R.

Becoming a Naturalist

In the pursuit of successful images, it is important to study your subjects and their environment. By learning about various connections and ecosystems, not only will you give yourself more opportunities to locate subjects, but you also will be able to portray them with respect and knowledge.

Familiarizing yourself with the areas you frequent will take you beyond relying on luck. You will know what time of day the light hits your front garden, when the butterflies usually visit the coneflowers, and when the tree bark reflects the golden glow of sunset. Learn which ecosystems certain flowers can be found in, and at what time of year. If you want images of butterflies, know what types of flowers they will be attracted to; there's no use waiting for butterflies in a tulip field. If you know that the sun's rays hit a certain red maple tree by a pond at 10 o'clock in the morning, you'll find wonderful reflection images waiting for you at just that hour.

Keep notes in a notebook or on a tape recorder. These can be transferred to a computer database and will be available to you from season to season. This process takes a little extra time, but it's well worth the effort.

Shell in autumn reeds. *It was a rainy day in Acadia National Park in Maine, and the saturation in the foliage was magical. I had been working on some scenic images, when I sat down on a log to relax and enjoy my surroundings. Right at my feet in the colorful reeds lay a shell that must have been dropped by one of the shorebirds. I hadn't been looking for macro images, but this one presented itself. This one small shell among threads of reds and browns represents that rainy fall day on the coast.* N. R.

Green darner emerging. *A pond environment yields many potential subjects. This green darner was a special gift on this spring morning. Having just emerged, and still wet with dew, it made a perfect subject.* N. R.

Being Creative

Beginners often want formulas and exact techniques. Taking risks is an important part of the photographic process, however. Comedian Woody Allen said, "If you're not failing every now and again it's a sure sign that you're not trying anything very innovative." Don't be afraid to make mistakes. Through trial and error, amazing discoveries are possible. Try a lens you've never used or a composition you're not sure will work. Put on a close-up filter and spend the whole morning viewing the world through that filter. Experiment with a wide-angle lens.

Explore other areas of the arts that may not necessarily seem related to photography. Visit museums and art galleries, and look at pictures in books and magazines. Viewing the results of other people's creative vision can stimulate your own creativity.

Know that your vision is unique. Each photographer sees and interprets things differently. Although you're not the only one to photograph a rose, your rose image will not be the same as anybody else's. You bring to that rose your own individuality and photographic vision. Each of your images is uniquely yours.

Composition

A detail is quite capable of eliciting a greater intensity of emotion than the whole scene evoked in the first place . . . because the whole of nature is too vast and complex to grasp quickly, but a fragment of it is comprehensible and allows the imagination scope to fill in the excluded setting.

—Eliot Porter

Photographers face the challenge of taking fragments of scenes and organizing them in such a way that the chaos and haphazard conditions of nature are expressed in a simple, orderly manner. This is the essence of composition. In close-up photography, this is even more important, as you're dealing with smaller fragments of the larger whole. Keep in mind that what doesn't add to the image subtracts from it. You must filter the information that the camera sees and select those elements that will best describe the subject as you wish to portray it. There are no laws, but there are some considerations and guidelines that can help you.

Defining Your Subject

You've probably had the frustrating experience of finding a worthy subject and photographing many frames of it, only to be disappointed upon reviewing the images.

In the field, when excitement is high, we often tend to quickly snap pictures without the necessary objectivity. Though fervent, impassioned photography is desirable, you need to be able to distance yourself from that passion in order to objectively edit your photos.

To help with this process, ask yourself, "What exactly is my subject?" Expand the analysis by asking, "What attracted me to this subject?" Run through a mental checklist of your subject's characteristics, and think about what makes it special and unique. Move from a vague sense of what you are photographing to a more concrete idea.

Sweep the edges. After deciding on your composition and subject placement, examine the borders of the frame for intrusive elements. In the excitement of the moment, did you miss an obtrusive branch or unwanted flower? Check the background for distracting things such as a bright leaf or a piece of trash. If you've oriented the subject horizontally, check to see how it would look vertically. We often shoot both horizontals and verticals of the same image. This gives us more marketing flexibility and provides us with the opportunity to decide at the light table, when we're not caught up in the excitement of the moment, which ori-

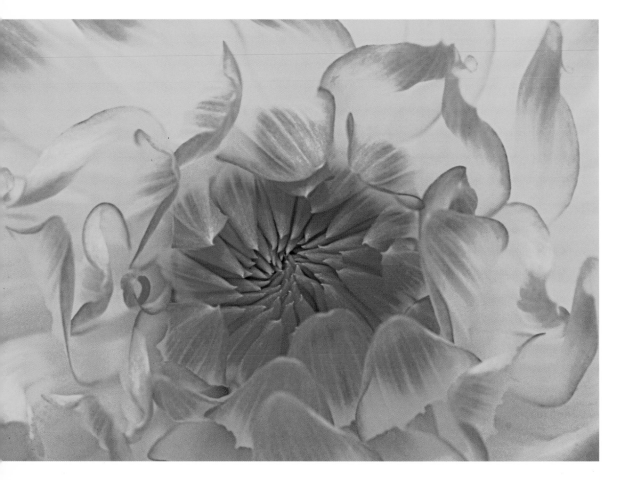

Backlit dahlia. *The sun was setting behind a garden of these incredibly large dahlias. Instead of trying to capture the whole garden, I looked for one dahlia that might represent the larger picture. This yellow one was in perfect condition and had conveniently grown in a perpendicular fashion, enabling the film plane to line up very easily. What was most impressive was the beauty of the light as it wrapped its glow around the edges of the petals. Rather than photographing the whole dahlia, including its circumference and surroundings, I moved in very close and eliminated anything that might distract from the relationship of light and petal. The dahlia was backlit, so I opened up one to one and a half stops to obtain detail in the shadows. Whenever the light seems a little tricky, bracket your exposures to be sure of getting the best shot.* N. R.

entation works best. Take a slow, deliberate look around the periphery of your image. Check for areas of brightness or unwanted elements that might interfere with the impact of your image. Take the time to view your subject from different angles, and try placing the subject in different positions in the frame. With practice, this whole process will become habit and actually takes very little time.

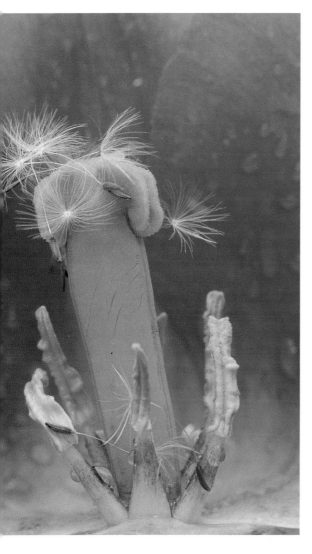

Seeds on tulip pistil. *What attracted me to this image was the interaction between the wind-blown seeds and the tulip pistil. I wanted a tight composition in which the seeds and the pistil seemed to exist in a world unto themselves. Placing a 5T close-up lens onto the 200mm macro lens provided me with greater-than-life-size magnification. Small details such as these are wonderful subjects to work with and offer viewers an opportunity to peek at a part of nature that is often missed.* N. R.

Pink lady's slipper buds. *It was drizzling as we drove along the road hunting for lady's slippers on Ontario's Bruce Peninsula. I took many different photographs, but I enjoy this one for its simplicity and lack of clutter. To me, these two buds appear to be responding to each other in a maternal or protective manner. Wanting this relationship to be the most important factor in the image, I made sure that there were no other competing elements by keeping the background out of focus.* N. R.

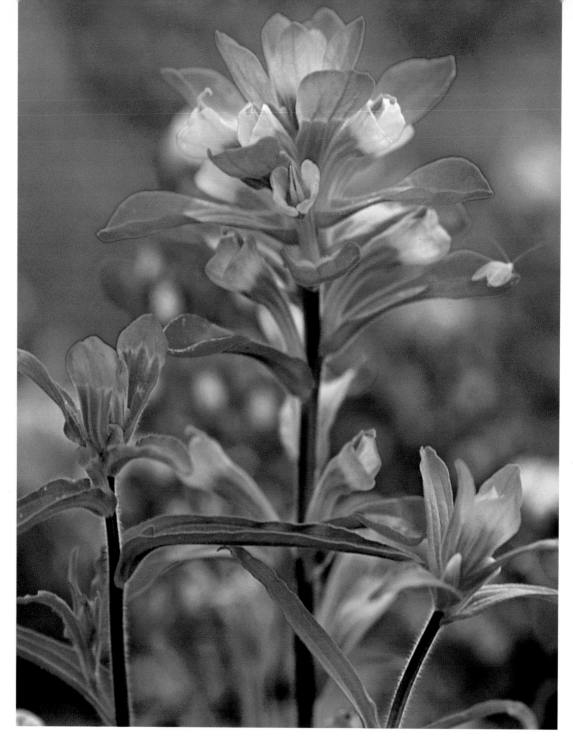

Indian paintbrush. *Fields of Texas wildflowers are a spectacular sight. I spent some time walking around this field of paintbrush and bluebonnets, searching for a composition in which the main subject would be the paintbrush but the background would imply the presence of bluebonnets.* N. R.

Right: Columbine. *Columbines have a quiet, almost tender nature, and I searched for a complementary background that would accentuate these delicate characteristics. The soft hues of the green grass provided the appropriate feeling. Using a wide aperture of f/5.6 and a 200mm macro lens, I narrowed down the background coverage and eliminated distracting elements.* N. R.

Below: Wild geranium in fern. *Spring in western Pennsylvania is always a welcome event. A green wave begins in April, and when the wildflowers start popping in May, so do our cameras. The season is so exciting that I must force myself to settle down and concentrate so that I don't miss the subtler events that are happening or overlook those details that are not immediately apparent. The simple design of this image wouldn't have been as successful if more flowers or ferns had been included. It tells the story just as it is, and I've added visual impact by allowing the pattern to continue to the edges of the frame, hinting at a continuous and persevering rhythm.* N. R.

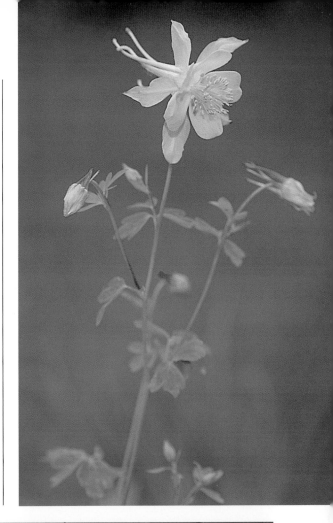

Left: Ferns unfolding. *Capturing the essence of the spring season was my goal while working with these ferns. I wanted only green in the image, so I cropped these unfolding ferns tightly, excluding all other forest colors. To get the ferns sharp, I had to lie down on the forest floor so that the film plane was parallel to the plants.* N. R.

Right: Seed on leaf. *This seed resembled a dancer as it lay on a maple leaf. I composed the picture so that the seed would be asymmetrical, situating it so that the veins of the leaf were part of the framing.* N. R.

Below: Garter snake in leaves. *Probably days before its winter retreat, we discovered this garter snake basking in the warmth of fall sunshine. Temperatures were cool, making it a cooperative subject. Wildlife photographers often try to include the entire subject in the frame. For this image, I felt that this wasn't appropriate; to me, the head and the way the leaf curled around it were the most important elements. The presence of the flicking tongue certainly adds to the interest of the image. To capture the motion of the tongue, I used TTL fill flash set at −1.5 stops.* N. R.

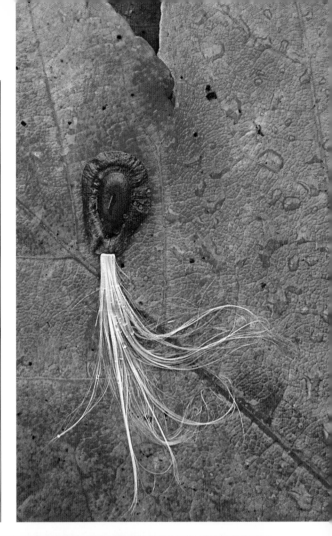

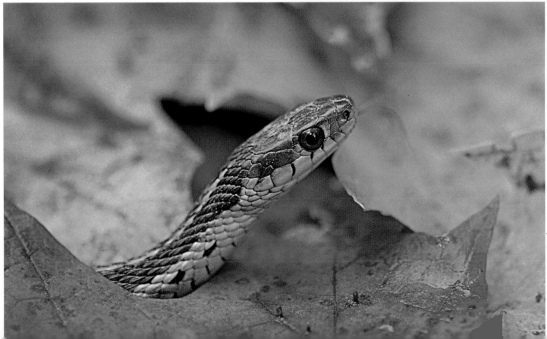

Backgrounds

In close-up photography, you are focused on one small magnified area. This causes every detail to be exaggerated. You therefore must be as conscious of backgrounds as you are about your subjects. A bad background can ruin an otherwise wonderful image.

Be conscious of background colors. Bright or shiny articles will drawn attention from the subject. Just a slight shift in camera position can often help. Spend time walking around your subject to check for a vantage point that gives you a better background. As you sweep the edges, watch for any background intrusion.

Use your depth-of-field preview button to check backgrounds. If you have a grid screen, examine each square. An excellent way to check backgrounds is to change the focus from your subject to the background. You'll be amazed at the twigs, leaves, and unwanted debris that will leap out at you.

Subject Placement

Imagine that your viewfinder is a tic-tac-toe-like grid. Using a grid screen makes this easy. The points of intersection on these grids are usually the best places to position your subject, creating images with the greatest impact. Placing subjects in the middle of the frame produces symmetrical images, which are often static and passive. Your images of creatures will usually have more impact if they are positioned along one of the grid lines. It's also best if they are looking into the frame, not out of it.

These are only guidelines, and not rules written in concrete. Be conscious of the preferred placements, but follow your own creative vision. Many successful images do not adhere to any placement rules.

Adding Interest

Shapes and Patterns

As your vision sharpens, you will become more aware of shapes and patterns. Curves give the feel of motion and growth. Spirals evoke life and death, rebirth, and harmony. Triangles represent strength and stability. It's a fun and useful lesson to look for these shapes in nature. Looking for the extraordinary in the ordinary is an exciting part of close-up photography. Ignore color and texture, and concentrate on the outlines of objects. If you have trouble doing this, a handy little filter, Zone VI from Calumet, eliminates color and shows just contrast and shape.

Repetition creates strong visual impact, especially when the pattern extends all the way to the edges of the frame. As it appears to flow beyond the frame, it hints at a continuous and persevering rhythm.

A close-up of one small part of nature can represent a larger whole. One shell on a beach surrounded by sand patterns conveys the feeling of being at the shore. An autumn leaf floating in a stream of red and orange reflections symbolizes the fall season.

Reflections

As light disperses into abstraction, blues and greens dance in cascading waterfalls, and yellows and oranges weave tapestries in autumn ponds. Reflections create visual metaphors, where red rock canyon hues and cottonwood leaves echo their glow into rivers and streams.

Reflections consist of ever-changing shapes, lines, textures, and motions. Move into different positions with your camera off the tripod to view the various combinations. When composing, the slightest alteration in position can create a great difference in the final image. You may have to try several positions before you discover a composition that works.

It's good to have a nonreflective object such as a rock or leaf in a reflection image to give the viewer something tangible to focus on. The shimmering color of the reflection forms a kaleidoscope background for the object.

Texture

Sometimes a photograph is not about the subject itself but rather about its physical properties, such as shape or texture. Things with wonderful textured surfaces, such as bark, leaves, shells, rocks, and flower petals, make excellent close-up subjects. The light that best reveals these textures is the low-angled light found in early mornings and late afternoons.

For the greatest impact, a textured surface needs to be sharp throughout the image. Keep the film plane parallel with the

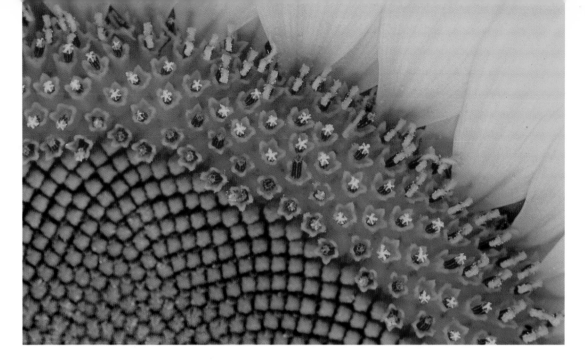

Sunflower head. *In this image, I chose to emphasize the very diversified seeds of a sunflower, with just a hint of the radiating petals. A gold reflector added to this flower's already sunny disposition.* N. R.

Goatsbeard seed head. *Abstractions are fun and make great close-up photographs. To show off the beauty of these seed heads, I isolated a fragment of the larger head. The design becomes a symmetrical one and is reinforced by the rhythm and repetition of its elements. An 81A filter emphasized the already golden color.* N. R.

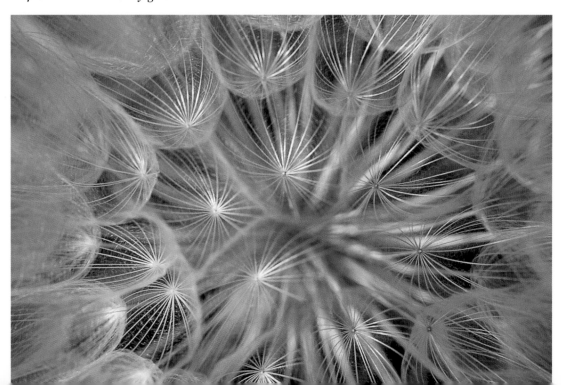

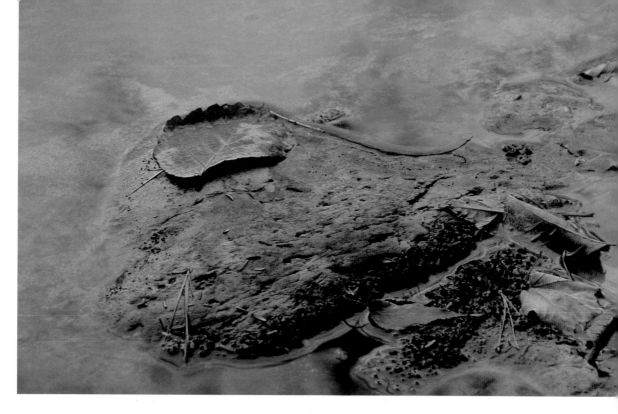

Reflections. *Both of these reflections were photographed only a few feet away from each other. Reflections have so many varieties of patterns and color combinations that just by moving your vantage point you can obtain a very different image.* N. R.

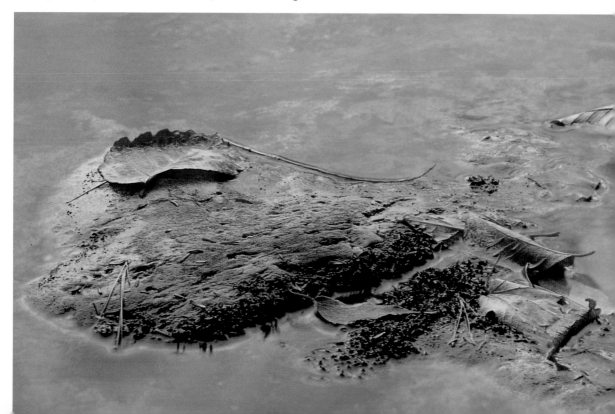

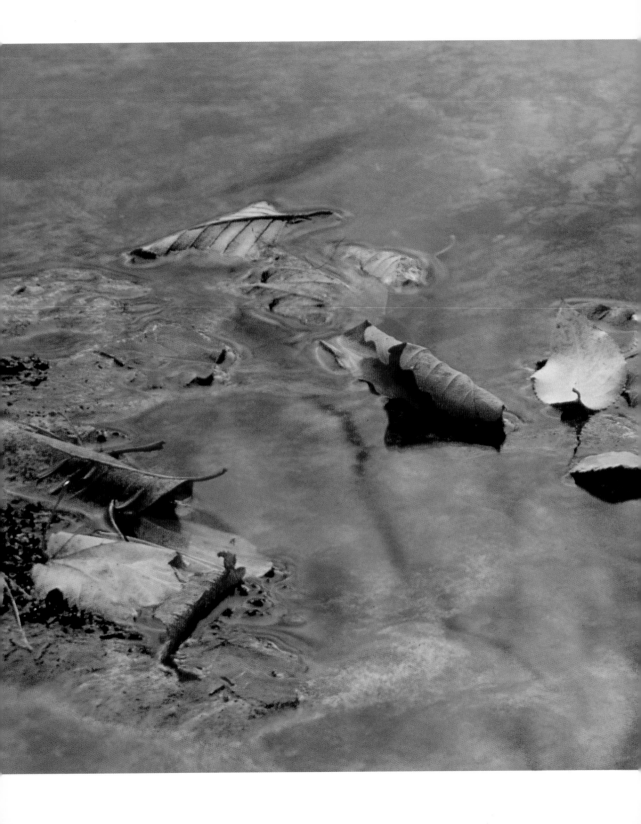

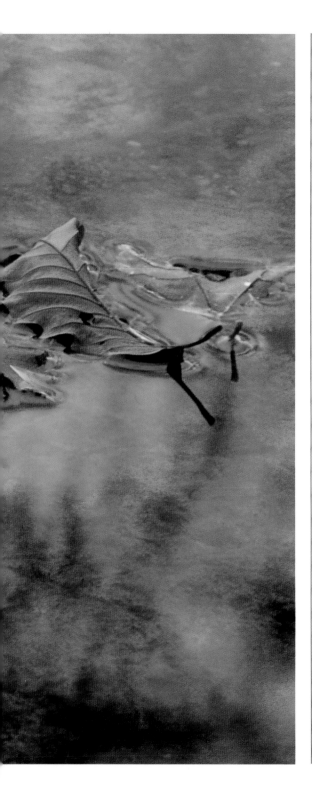

subject, and stop down your lens to achieve sufficient depth of field. If some points or curves are higher than others, focus on the highest point—the one closest to your lens—and stop down to bring the rest of the image into focus.

Special Effects

Vignetting

When vignetting, an out-of-focus foreground is used to frame and isolate the subject. You shoot through one foreground object while focusing on another that is farther away. The material you shoot through can be growing naturally, such as grasses, or hand-held in front of the lens, such as a bunch of leaves. Whatever you use as a frame must be as close as possible to the lens and out-side of its focusing range. If it is within the field of sharp focus, it can compete for the viewer's attention instead of simply masking part of the subject. An object that is only slightly out of focus draws the eye and chal-lenges the viewer to identify it; something that is totally blurred is much less intrusive into the viewer's field of awareness.

Vignetting works best with a shallow depth of field, which eliminates extraneous detail in the background and foreground.

Leaves in fall color reflection. *The Big Moose River in New York's Adirondacks is one of my favorite photographic destinations. I can spend days enjoying its magic. When the sun shines in the fall, the red and yellow maples lining the riverbank are reflected in its water. Whenever the elements of sun, foliage, and water are present, chances are you will find reflections. Reflections are not always obvious; sometimes you need to wander along the bank and crouch in many different positions. Here I used a 200mm macro lens to reach out into the water.* N. R.

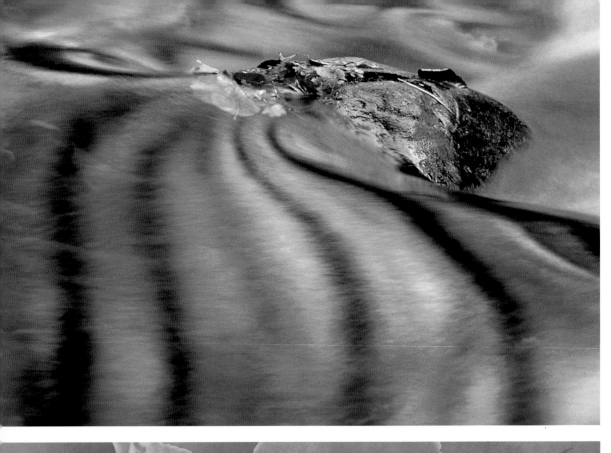

Left top: Reflecting tree trunks. *Rather than photograph the tree trunks by the side of this stream, I chose to create a more abstract, Monetlike image by focusing on their reflections. I placed a rock as a stabilizing object, and then composed the abstraction around it.* N. R.

Left bottom: Desert succulent. *This succulent was growing in the Sonoran Desert of Arizona. It was early in the day, and there was still shade on it. The cool bluish light of morning enhanced the natural blue color of the plant. When deciding how much of the subject's detail to leave in, I chose to exclude some of the top petals, giving strength to the center. I used an aperture of f/22 to increase the depth of field. One rule of photography is to never bull's-eye your image. It's important to be aware of such rules, but you should feel free to break them in order to create an image that pleases you. Don't let rules stifle your artistic vision.* N. R.

Mayapple. *I have always found the mayapple difficult to photograph, with its blossom hanging below a canopy of leaves, facing down toward the earth. This particular mayapple, in Raccoon State Wildflower Preserve in western Pennsylvania, was growing halfway up a hill, enabling me to shoot from below the level of the blossom. I tried to convey the semihidden nature of this flower by vignetting it through a curtain of grasses. A through-the-lens spot meter reading was taken from the surrounding medium-toned foliage.* M. L.

The best images that use this technique are generally those shot at f/4 to f/5.6. Always evaluate the result of vignetting with your depth-of-field preview button before exposure.

Keep the blurred areas at the edges of the frame. Avoid having a region of sharp focus outside the vignette, between the blurred area and the edge of the frame. This can be very distracting and ruin the vignette.

It's usually best to shoot through a color that is complementary to the subject and does not compete or clash, although you can occasionally achieve an exciting image by creating visual tension between colors. Avoid anything brighter than the subject. A bright spot at the edge of the image, even if out of focus, tends to draw the eye away from the subject.

Take a meter reading before vignetting so your meter will not be fooled by a frame

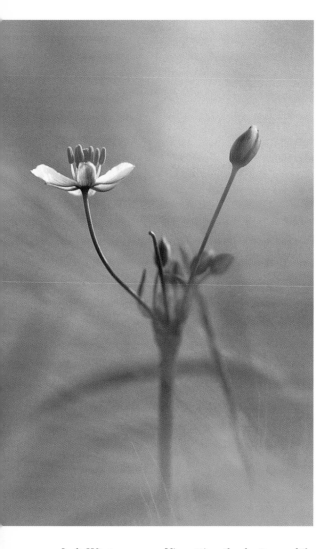

Left: Wintergreen. *Vignetting the bottom of the wintergreen's rather bare stem softens its emergence into the frame.* N. R.

Right: Seed heads, Mount Rainier. *Vignetting not only softened the lighting, but also produced out-of-focus streaks which add a sense of texture to this image.* M. L.

that is lighter or darker than your subject. Through-the-lens spot metering can be very helpful in these situations, if your camera provides that function.

When using TTL macro flash, aim the flash head over or around the material you're shooting through. If the light from the flash strikes it first, the exposure may be incorrect or shadows may be cast upon the subject.

Through judicious application of this technique, you can soften the area sur-

rounding a subject, thus removing distracting influences and creating a visual tunnel effect. Vignetting is a solution to having flower stems arise abruptly from the edge of the frame or busy foregrounds that distract from a lovely subject. It does not require fancy lenses, filters, or special cameras; it simply takes imagination, patience, and the willingness to break a few rules and master a few others.

Soft Focus

Soft focus can add a hint of mystery or romance to your close-up images. Soft-focus treatment may not be suitable for some subjects, but for flowers, butterflies, and other subjects that might lend themselves to a romanticized presentation, it can be very effective. There are many ways of achieving soft focus.

Soft-focus filters are simply screwed onto the front of the lens. You can purchase one or make one yourself from an inexpensive skylight filter covered with Vaseline or mesh, such as a piece of a nylon stocking.

Specialized soft-focus lenses are manufactured for use in portraiture. Most of them are expensive, but the soft-focus effect is adjustable. The Sima Soft Focus lens, long out of production, is an inexpensive plastic lens (100mm f/4) with a trombonelike focusing mechanism yielding 1:1 magnification. The soft-focus effect could be adjusted by

using several interchangeable diaphragms, each containing a different-size aperture. These lenses can occasionally be found on dealers' back shelves.

Another type of soft-focus effect can be achieved by creating a double exposure. For multiple exposures, the sum of the two exposures must equal the correct exposure. If, for example, the correct exposure is based on a shutter speed of 1/125 of a second, then take each exposure at 1/250 of a second. Take your first image, carefully focused. Then, for

Goatsbeard. Springtime in the Colorado Rockies comes in July, and snow is often still present at higher elevations. The region between Crested Butte and Ouray is one of our favorites for wildflowers. The softness of this goatsbeard on the road to Yankee Boy Basin was emphasized by vignetting through surrounding grasses. The neutral palette of Ektachrome 100S helps maintain the feeling of softness, and a half stop overexposure makes the colors a bit more pastel. M. L.

Cineraria. *An inexpensive soft-focus filter was used for this image of a cineraria in the Highland Park Conservatory in Rochester, New York. I'm always struck by the irony of placing a $15 filter on the front of an $800 lens.* M. L.

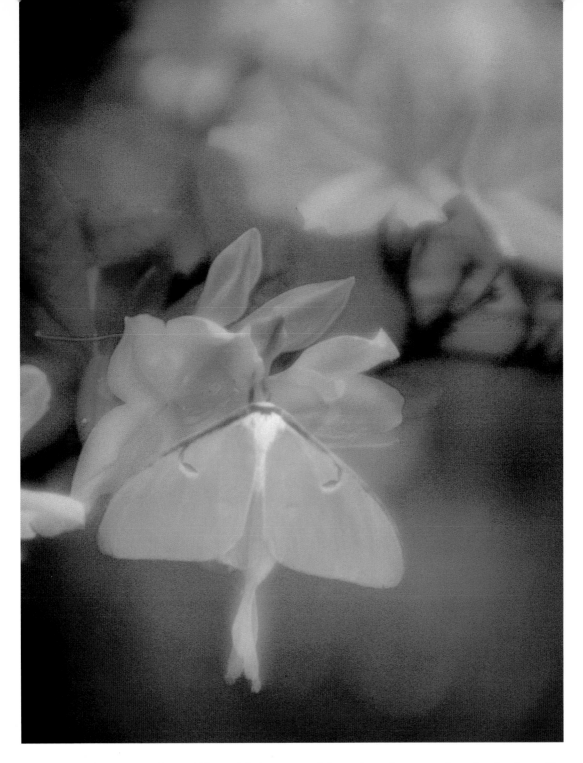

Luna moth. *Shot with a Sima 100mm f/2.8 macro soft-focus lens, long out of production but still available on some dealers' back shelves. The plane of the camera back was held parallel to the plane of the wings to maximize depth of field at a wide aperture. The soft-focus technique seems to work best with simpler and more graphic subjects.* M. L.

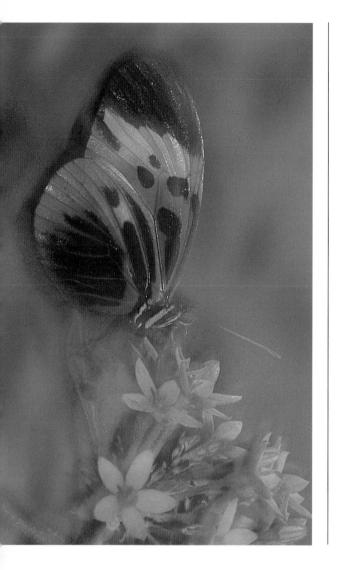

Soft-focus double exposure. *In the Butterfly House at Calloway Gardens, this butterfly was enjoying breakfast and posed, unmoving, for quite a long time. The first exposure was taken without flash, at the recommended available light exposure. The second was shot with fill flash at –1.5. For the second exposure, the lens was defocused slightly to add a slightly blurred halo effect to the original sharp image.* M. L.

the second exposure, throw the image slightly out of focus, in the direction that makes the out-of-focus image slightly larger than the sharp image. The camera must be tripod-mounted, since exact registration of the two images is necessary. In the final images, there will be a pleasing halo around the subject.

It is easy to overdo these special techniques—be subtle! As is often the case, the most effective techniques are those which are "transparent" and do not attract attention to themselves.

A good craftsman leaves no traces.

Zen proverb

Ethics and Etiquette

The natural world is a precious place whose future depends on our honor and respect. As an integral part of this natural world, we, as photographers, have a special responsibility to be sensitive to the environment whenever we are in the field. Harassing animals, intruding on their habitats, or driving off-road through patches of wildflowers are breaches of etiquette.

As we zealously pursue images, we should take care to preserve our subjects. If a flower doesn't complete its bloom and produce seeds, it will not reproduce and, in fact, may take many years to recover. If you remove dead branches or leaves from around your subject, return them. Some plants rely on the

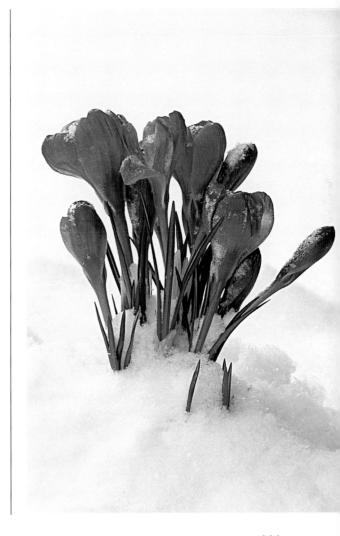

Crocus in snow. *It seemed as though this Pennsylvania winter was going to last forever, and I needed an infusion of film in my camera. The photographic soul rebels and twitches when it's not being gratified. There was a lot of snow outside, and all day I had been staring at this lovely purple potted crocus sitting on my desk. Then I had an idea. I took my supermarket crocus outside, found a desirable location, and buried it in the snow, creating something that could happen in nature. The crocus suffered no harm, and I was ready to put up with a few more weeks of winter.* N. R.

Above: Sunflower petals and seeds. *Some sunflower petals had dropped onto our kitchen floor. In a bowl on the table were some sunflower seeds. Thinking that they'd make an interesting graphic combination and tell a story, I combined the two separate but related elements. All around our house are potential subjects such as rocks, shells, flowers, plants, pieces of glass, and cut flowers. We surround ourselves with beauty, keeping our vision stimulated and open for possible photographic ideas.* N. R.

Right: Autumn leaves on barn door. *I discovered this old barn door on a country road. The door itself made an interesting subject, but what was most intriguing was the grain of the wood and the rusty hinge. I put on a macro lens for a tighter vignette. Seeing the colorful leaves on the ground below, I scooped up a handful and threw them at the door. For me, this image represents a wonderful fall day on that country road.* N. R.

decay of dead materials for nutrients. Transplanting flowers to other, more convenient habitats interferes with the natural ecosystem and disturbs the environment for other photographers and nature lovers.

Cleaning up debris is one thing, but removing living specimens may be illegal. Carry along string and green Velcro strips to tie back branches that interfere with your compositions.

If you move insects or other specimens to photograph them, do so very carefully and quickly, and then replace them in their natural environment when finished. Some photographers place insects, amphibians, or reptiles in the refrigerator for a short period of time. The resulting hypothermia causes the cold-blooded animal to be passive and easily managed. You can, however, use a less drastic tactic. Get up early in the morning and photograph butterflies and moths while their bodies are heavy with dew and the sun has not yet warmed their wings. Amphibians and reptiles, being cold-blooded, are also less active in morning and evening.

No camera club ribbons or compliments from editors are worth jeopardizing our fragile environment. We have a responsibil-

Sunflower and blue flag iris. *It was late summer, and our garden sunflowers were at their peak. They were just right for photographing, but I also wanted to create a story about color, so I went to my neighborhood florist and scouted around for some complementary flowers. These irises with their yellow centers were just the thing. Wanting sharpness throughout, I kept the flowers as close to the same plane as possible. I photographed them in shade to help minimize the blue shift that happens because of ultraviolet reflectance. This simple composition about color and design has been one of my most successful commercial images.* N. R.

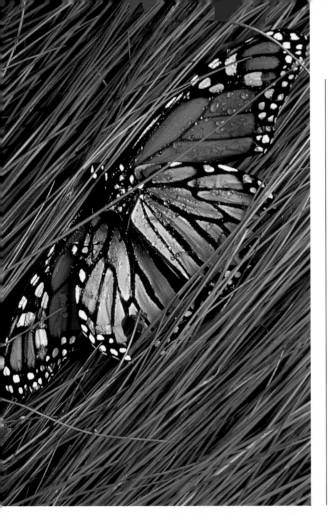

Left: Monarch butterfly in reeds. *This monarch butterfly was lying on a road. It had obviously met with some accident, but was beautiful even in death. Not wanting to photograph the butterfly on the road, I moved it to some reeds that were similar in color to the golds and oranges of the butterfly. Often we look for subjects that are not damaged or torn, but nature's story does not include only perfect specimens.* N. R.

Below: Frog couple. *This green tree frog couple seemed to be enjoying a relaxing time. In nature, these tree frogs wouldn't be found on an apple blossom branch, but for our workshops, we set them up on all kinds of props. I have no problem with photographing them on a variety of things, but I always label the images "captive subjects." After ensuring that the background did not compete with the subjects, I used fill flash set at −1.5 to bring out the details in the frogs.* N. R.

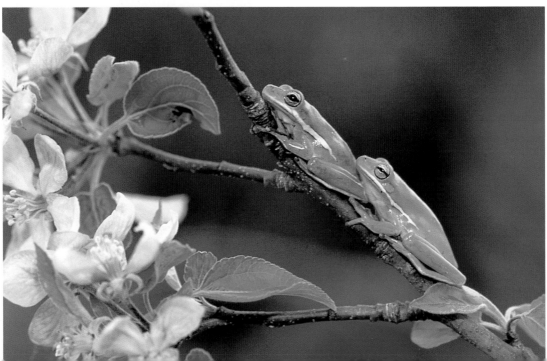

ity to ensure that our subjects will survive in their natural habitat, not just in our photographs. Through our photography, we have the opportunity to provide the world with visible reminders of what is worth preserving.

Truth in Imaging

There should be an honesty in your photography when portraying the natural world. Sunflowers don't grow beside tulips, and daffodils don't grow with cactus. This may sound obvious, but some photographers, in their eagerness to create outstanding images, get a little carried away. It's okay to experiment with unusual combinations as long as your images are presented with honesty and no attempt is made to represent them as natural. The average person may not know the difference between a staged photo or one shot in the field, but it's a matter of ethics to caption your images accurately.

In our greenhouse, we often hatch various species of butterflies and moths as subjects for our workshop participants. We make sure that the species we purchase are indigenous to our area, or we keep them until they die naturally. That way when the shoot is over, we can release the subjects to a natural habitat without jeopardizing the ecosystem.

We also purchase various species of tree frogs and lizards to be used in setups. We maintain them in natural habitats that we have built, and we enjoy and care for them as pets. Because we photograph these creatures in a manipulated environment, we are careful to caption the photographs accordingly.

Consideration should also be given to other photographers. Don't invade another photographer's space. It is distracting to have someone else's tripod legs wrap themselves around yours while you are trying to concentrate. If a fellow photographer is working with a creature, you risk frightening it and ruining the photo if you come too close.

Favorite Close-up Locations

There is really no end to the list of potential locations, and of possible subjects to photograph. The key to successful location photography lies in your openness to respond to wherever you are and your ability to connect with whatever subject you are photographing.

A good photo workshop or tour will take you to the right place at the right time and will save you precious time in scouting. It gives you the opportunity to share with like-minded folks and enjoy the camaraderie, provides a wonderful place to learn and be encouraged, and introduces you to areas you might never venture to on your own. Before you sign up, find out how much field time and classroom time are planned. Ask how strenuous the outings will be and what level photographer they will be directed at.

Our Backyard

Our favorite place to photograph is right where we live in Pennsylvania. We are fortunate to live on a farm with all of its treasures, but there are wonderful things to be found wherever you live. Many people seem to think that if they're not traveling to some exotic location, there are no images to be found. It's a fact, however, that not only are the local images our favorites, but often they are the ones that have done the best for us commercially.

Aside from the farm itself, we are fortunate to live just a few short miles from several other fruitful hunting grounds. About 10 miles from us in western Pennsylvania there is a wonderful wildflower preserve called Raccoon Creek State Park. In early spring, visitors are treated to acres of trillium, phlox, wild geranium, spring beauties, trout lily, orchids, bluebells, and fern. Deer, wild turkeys, and toads are also in residence.

A few miles farther is Independence Marsh. Early-morning fog is the norm for this very prolific marshland. Canada geese, mallards, and herons can be found here, as well as deer and raccoons. In early spring, the hillsides are covered with trillium and wild violets, and at the end of the summer, we find dragonflies, Joe Pye weed, teasel, and amazing dew-laden spiderwebs.

The Adirondacks

Another favorite photo location is the Adirondack Mountains of upstate New York. Each season in this location provides photo opportunities. In fall, we work with reflections on the many streams and lakes; in spring, wildflowers, waterfalls, and mossy logs keep us busy. Winter offers ice patterns and frosty vegetation. If you're comfortable carrying equipment while cross-country skiing, the Adirondacks will reward you with many more exciting subjects on hundreds of trails.

We have a particular fondness for the area around Old Forge, Blue Mountain Lake, and Lake George. After many years of photographing there, the Big Moose River, Raquette Lake, and the many hiking trails feel like old friends.

The Oregon Coast

The southern Oregon coast, from Florence to Bandon, is less populated than the northern coast and provides wonderful opportunities for close-ups. There are some 350 miles of public-access coastline, giving a photographer plenty to explore. The beaches are alive with texture and pattern, and at low tide, you are treated to sea stars, shells, anemones, snails, rocks, feathers, and lichen. Take along rubber boots, and be prepared to lose yourself in the magic. Good shooting locations for marine life and tidepools along the entire coast include Indian Head Beach, Cannon Beach, Moolack Beach, Seal Rock, Marine Gardens, and Strawberry Hill. Tide charts are available at fish and bait stores.

At Shore Acres State Park, near Coos Bay, there are flowers year-round, including hundreds of spring bulbs, rhododendrons, azaleas, roses, and the largest dahlias we've ever seen. A walk to the cliffs of this wonderful park will reveal pounding surf and bizarre rock formations.

Texas Hill Country

If hills of blue, red, and yellow wildflowers make your heart sing, plan a trip to Texas in the spring. In the Hill Country of south-central Texas, within the triangle formed by the towns of Llano, Buchanan Dam, and Fredericksburg, paintbrush, bluebonnets, phlox, and mallow provide rainbows of color along the highways, a boon for those who don't wish to hike. Parking is prohibited along some roads, but most spots invite appreciative photographers. Butterflies and hummingbirds are prolific, and a visit to almost any field first thing in the morning will be rewarding.

Many images can be found just by driving around on the Hill Country roads, parking, and working specific areas. There are also some particular places that are worthy of a stop: McKinney Falls State Park, Enchanted Rock State Park, Willow City Loop, the entire Lake Buchanan area, and the L.B.J. Ranch. Call the National Wildflower Center, (512) 292-4100, to find out what's blooming where and when.

Zion National Park

We love the Southwest for its light and beauty. For close-up images, we always seem to return to Zion National Park in Utah. In one fall day, you can photograph reflections in the Virgin River, patterns in the rocks at Emerald Pools, cottonwood leaves by the roadside, textures in sawtooth maples, and the lines of sandstone in canyon walls. We often stay in Springdale, which is a short drive into Zion, or at the Zion National Park Lodge, in the park itself, so that we can be in the park for first light each morning.

While photographing in the Southwest, be careful when loading your camera. Little bits of sand float in the air, and one tiny particle can land unnoticed on the strip of film. That one little piece of sand can cause a scratch through every frame.

Colorado

July is summertime where we live, but it's springtime in the mountains of Colorado. Alpine meadows filled with flowers and backgrounds of snow-capped mountains await you and your camera. At higher elevations, you'll find tundra vegetation and lichen.

Our favorite areas for close-up photography are around Crested Butte, Yankee Boy Basin, and Ouray, in the western part of the state. Fields of paintbrush, columbine, and

119

lupine will fill your days. Due to the elevation, the sun is extremely strong, so we always go up to the mountains in the morning, while it's still dark. We descend around the noon hours, and return for late light. We generally rent a four-wheel-drive vehicle on our trips to Colorado so we can travel on the many jeep routes and the high passes to the alpine meadows.

Florida

Mickey Mouse has made Florida a busy spot, but there are places here that still allow for peace and quiet, as well as close-up opportunities. Off times for tourists are usually good times for photographers.

There are not many vacationers on the beaches before 9 A.M., and most people go shopping on overcast days.

Sanibel and Captiva Islands, on the west coast of Florida just a short drive from Fort Myers, are famous for some of the best shelling in the world. Sanibel Island is best known as the home of the J. N. "Ding" Darling National Wildlife Refuge, long a mecca for birders and photographers. Nearby on Sanibel is the Bailey Tract, a less well-known but equally interesting area, particularly for close-up photographers. This was the site of an old airstrip, with an overgrown canal that's home to green tree frogs, alligators, turtles, anoles, and lizards.

Gambel oak in frost. We found this Gambel oak leaf lying in an area of frost on a hike up Checkerboard Mesa in Zion National Park. The colder temperatures at higher elevations like this give a cool, blue appearance to subjects. I wanted the leaf to be the prominent subject but to also show its frosty environment. N. R.

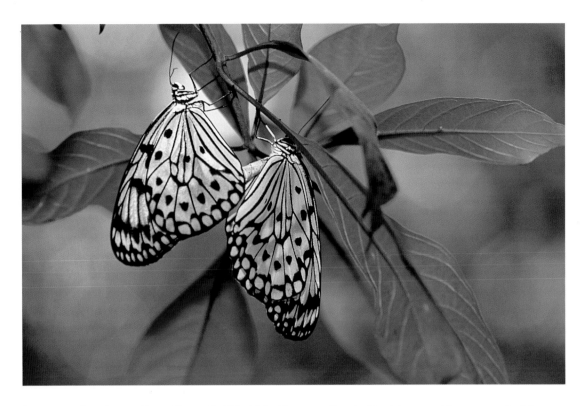

Japanese kite butterflies. *Butterfly World in Coconut Creek, Florida, provides a wonderful arena in which to photograph butterflies. It does not, however, allow the use of tripods. We knew this in advance and were prepared with long lenses and flash units. These Japanese kite butterflies were photographed hand-held, with a 200mm macro lens and an SB24 flash unit set for fill flash at −1.5.* N. R.

In Everglades National Park, the major attraction is the wading birds, but there is significant potential for close-up photography on the Anhinga Trail boardwalk across the Taylor Slough, just south of the visitor center. Keep your eyes open for tree frogs, anoles, turtles, baby alligators, tree snails, spiders, and butterflies. Walk the Gumbo Limbo Trail, which begins at the Anhinga Trail ranger station, for more opportunities, including tropical trees with incredibly photogenic bark. As you drive south in the park toward Flamingo, stop at Mrazek and Eco Ponds. Again, the main attraction is the birds, but the trails around and alongside the ponds yield a wealth of close-up subjects. South of the campground at Flamingo, the mangroves along Florida Bay offer hermit crabs, coconuts, giant nephila spiders, and assorted butterflies.

Farther northwest in the Everglades, outside the boundaries of the national park, is Corkscrew Swamp Audubon Sanctuary, famed for its wood stork rookeries. The park has a rich habitat filled with orchids, bromeliads, and wildflowers.

RESOURCES

Photographic References

Books

Angel, Heather. *The Book of Close-up Photography.* New York: Alfred Knopf, 1983.

———. *How to Photograph Flowers.* Mechanicsburg, PA: Stackpole Books, 1998.

Blacklock, Craig, and Nadine Blacklock. *Photographing Wildflowers.* Minneapolis, MN: Voyageur Press, 1987.

Braasch, Gary. *Photographing the Patterns of Nature.* New York: Amphoto, 1990.

Dalton, Stephen. *Secret Visions.* Topsfield, MA: Salem House Publishers, 1988.

Ericksenn, Lief, and Els Sincebaugh. *Adventures in Close-up Photography.* New York: Amphoto, 1985.

Hicks, Paul. *Photographing Butterflies and Other Insects.* Surrey, UK: Fountain Press, 1997.

Lefkowitz, Lester. *The Manual of Close-up Photography.* New York: Amphoto, 1979.

Lepp, George. *Beyond the Basics.* Los Angeles: Lepp and Associates, 1993.

———. *Beyond the Basics II.* Los Angeles: Lepp and Associates, 1997.

Meehan, Joseph, and Art Gingert. *The Art of Close-up Photography.* Surrey, UK: Fountain Press, 1994.

Nichols, Clive. *Photographing Plants and Gardens.* Devon, UK: Brunel House, 1994.

Nuridsany, Claude, and Marie Perennou. *Microcosmos: The Invisible World of Insects.* New York: Stewart, Tabori, and Chang, 1996.

———. *Photographing Nature.* New York: Oxford University Press, 1976.

Patterson, Freeman. *Photography of Natural Things.* Toronto, Canada: Van Nostrand Reinhold, 1982.

Rokach, Allen, and Anne Millman. *The Field Guide to Photographing Flowers.* New York: Amphoto, 1995.

———. *Focus on Flowers* New York: Abbeville Press, 1990.

123

Shaw, John. *Close-ups in Nature.* New York: Amphoto, 1987.

———. *John Shaw's Focus on Nature.* New York: Amphoto, 1991.

———. *The Nature Photographer's Complete Guide to Professional Field Techniques.* New York: Amphoto, 1984.

West, Larry, and William Leonard. *How to Photograph Reptiles & Amphibians.* Mechanicsburg, PA: Stackpole Books, 1997.

West, Larry, and Julie Ridl. *How to Photograph Birds.* Mechanicsburg, PA: Stackpole Books, 1993.

———. *How to Photograph Insects & Spiders.* Mechanicsburg, PA: Stackpole Books, 1994.

White, William. *Close-up Photography.* The Kodak Workshop Series. Rochester, NY: Eastman Kodak Co., 1984.

Anthologies and Technical Publications

Close-up Photography. A Kodak Technical Publication, N12A. Rochester, NY: Eastman Kodak Co., 1969.

Macrophotography. A Kodak Technical Publication, N12B. Rochester, NY: Eastman Kodak Co., 1969.

Videotapes

The Nature Photography Workshop Series, by John Shaw, available from Frank Hughes Productions, Suite 723, 4944 Lower Roswell Rd., Marietta, GA 30068-4321. A comprehensive introduction to almost all aspects of nature photography, including two tapes specifically devoted to close-up photography.

Nature Photography, an Advanced Photography Series video produced by Kodak Video Programs, Eastman Kodak Co., Rochester, NY 14650. Includes a section devoted to close-up photography, by Steve Diehl and Vici Zaremba. It is out of print but worth having if you can find it. Try camera stores and catalogs.

Periodicals

Camera Arts
1400 S St., Suite 200
Sacramento, CA 95814

LensWork Quarterly
LensWork Publishing
P.O. Box 22007
Portland, OR 97269

The Natural Image
George D. Lepp and Associates
P.O. Box 6240
Los Osos, CA 93412
(805) 528-7385

Nature Photographer
P.O. Box 2037
West Palm Beach, FL 33402-2037
(407) 586-3491

Nature's Best Photography Magazine
P.O. Box 10070
McLean, VA 22102
(800) 772-6575

Outdoor Photographer
12121 Wilshire Blvd.
Los Angeles, CA 90025-1175
(310) 820-1500

Petersen's Photographic
6420 Wilshire Blvd.
Los Angeles, CA 90048-5515
(213) 782-2200

Photograph America Newsletter
Pacific Image
1333 Monte Maria Ave.
Novato, CA 94947
(415) 898-3377

Photo Life
Toronto-Dominion Centre, Suite 2550
P.O. Box 77
Toronto, Ontario M5K 1E7
(800) 905-PHOT(O)

Photo Traveler
P.O. Box 39912
Los Angeles, CA 90039
(213) 660-0473

Popular Photography
1633 Broadway
New York, NY 10019
(800) 876-6636

Shutterbug's Outdoor and Nature Photography
5211 S. Washington Ave.
Titusville, FL 32780

Esthetics References

Adams, Robert. *Beauty in Photography*. New York: Aperture Foundation, 1996.

———. *Why People Photograph*. New York: Aperture Foundation, 1994.

Barnbaum, Bruce. *The Art of Photography: An Approach to Personal Expression*. Granite Falls, WA: Photographic Arts Editions, 1991.

Berger, John. *About Looking*. New York: Vintage Books, 1980.

Berger, John, and Jean Mohr. *Another Way of Telling*. New York: Pantheon Books, 1982.

Briggs, John. *Fractals: The Patterns of Chaos*. New York: Touchstone Simon & Schuster, 1992.

Cameron, Julia. *The Artist's Way*. New York: The Putnam Publishing Group, 1992.

Finn, David. *How to Look at Photographs: Reflections on the Art of Seeing*. New York: Harry N. Abrams, 1994.

Foy, Sally. *The Grand Design: Form and Colour in Animals*. London: J. M. Dent & Sons, 1982.

Franck, Frederick. *The Zen of Seeing: Seeing/Drawing as Meditation*. New York: Vintage Books, 1973.

———. *Zen Seeing, Zen Drawing: Meditation in Action*. New York: Bantam Books, 1993.

Freeman, Michael. *Image: Designing Effective Pictures*. New York: Amphoto, 1988.

Hill, Martha, and Art Wolfe. *The Art of Photographing Nature*. New York: Crown Publishers, 1993.

MacDonald, Joe. *Designing Wildlife Photographs*. New York: Amphoto, 1992, 1994.

Marx, Katherine. *Right Brain/Left Photography: The Art and Technique of 70 Modern Masters*. New York: Amphoto, 1994.

Meyers, Steven J. *On Seeing Nature*. Golden, CO: Fulcrum, 1987.

Patterson, Freeman. *Photographing the World Around You*. Toronto, Ontario: Key Porter Books, Ltd., 1994.

———. *Photography and the Art of Seeing*. Toronto, Ontario: Key Porter Books, Ltd., 1985.

————. *Photography for the Joy of It.* Toronto, Ontario: Key Porter Books, Ltd., 1986.

Samuels, Mike, and Nancy Samuels. *Seeing with the Mind's Eye: The History, Techniques, and Uses of Visualization.* New York: Random House, 1975.

Satterwhite, Joy, and Al Satterwhite. *Satterwhite on Color and Design.* New York: Amphoto, 1986.

Zuckerman, Jim. *Creating Dynamic Photographs with Visual Impact: The Art of Effective Composition.* Los Angeles: HP Books, 1990.

————. *Secrets of Color in Photography.* Cincinnati: Writer's Digest Books, 1998.

Natural History References

The Audubon Society Field Guide Series. New York: Alfred A. Knopf.

Birren, Faber. *Color and Human Response.* New York: Van Nostrand Reinhold, 1978.

————. *Principles of Color.* West Chester, PA: Schiffer Publishing, 1987.

Dennis, John V., and Mathew Tekulski. *How to Attract Butterflies and Hummingbirds.* San Ramon, CA: Ortho Books, 1991.

Lynch, David, and William Livingston. *Color and Light in Nature.* New York: Cambridge University Press, 1995.

Sedenko, Jerry. *The Butterfly Garden.* New York: Villard Books, 1991.

Stokes, Donald, and Lillian Stokes. *The Butterfly Book.* New York: Little, Brown, and Co., 1991.

Villiard, Paul. *Moths and How to Rear Them.* New York: Dover Publications, 1975.

Equipment

Beatty Systems
2407 Guthrie Ave.
Cleveland, TN 37311
(800) 251-6333
Manufactures interchangeable viewing screens, which make focusing in dim light a bit easier. Also customizes screens for all different brands of cameras with grids, full frame marks, and so forth.

Brightscreen
1905 Beech Cove Dr.
Cleveland, TN 37312
Manufactures interchangeable viewing screens. Also customizes screens for all different brands of cameras with grids, full frame marks, and so forth.

Century Precision Optics
10713 Burbank Blvd.
North Hollywood, CA 91601
(818) 766-3715
High-quality optics, including lenses and close-up diopters. Mostly supplies professional cinematographers, but has some equipment for still photography as well. High optical-quality long telephoto lenses, some manual aperture with no automation. Also manufactures custom adapters for attaching lenses of one manufacturer to camera of another.

Ikelite Corporation
50 W. 33rd St.
Indianapolis, IN 46208
(317) 923-4523
Manufactures a unique slave unit for cord-free, multiple-flash TTL close-up photography.

Kirk Enterprises
4370 E. U.S. Highway 20
Angola, IN 46703
Manufactures Arca-Swiss-style quick-release plates, macro brackets, and other accessories.

Laird Tri-Pads
P.O. Box 1250
Red Lodge, MT 59068
(406) 446-2168
Supplier of tripod leg pads to cushion and insulate tripod legs.

L. L. Rue Enterprises
138 Millbrook Rd.
Blairstown, NJ 07825
Maintains a comprehensive stock of useful equipment, as well as an excellent selection of current books.

Lumiquest
140 Helmer, Suite 775
San Antonio, TX 78232
Produces mini-diffusion screens for flash units.

Maxwell Precision Optics
P.O. Box 33416
Decatur, GA 33033-0146
Manufactures or upgrades focusing screens. Can customize.

Photoflex
333 Encinal St.
Santa Cruz, CA 95060
(800) 486-2674
Manufactures Litedisc diffusion and reflector screens, as well as LiteDome accessories for modification of electronic flash.

Photographic Solutions, Inc.
7 Granston Way
Buzzard's Bay, MA 02532
Manufactures PEC-12, non-water-based film cleaner.

Really Right Stuff
P.O. Box 6531
Los Osos, CA 93412
(805) 528-6321
Designs and manufactures Arca-Swiss-style quick-release plates for cameras and lenses, macro flash brackets, and close-focusing rails. Bryan and Kathy Geyer's catalog is well worth reading, just from an educational standpoint.

Singh-Ray Corporation
2721 SE Highway 31
Arcadia, FL 34266
(800) 486-5501
Manufactures truly neutral (no color cast) graduated neutral-density filters and warming polarizing filters.

Stroboframe Flash Brackets
The Saunders Group
21 Jet View Dr.
Rochester, NY 14624
(716) 328-7800
Manufactures flash brackets and accessories for 35mm and medium-format cameras.

F. J. Westcott Co.
P.O. Box 1596
Toledo, OH 43603
Manufactures diffusers and other light-modifying apparatus.

Biological Resources and Specimens

Carolina Biological Supply Co.
2700 York Rd.
Burlington, NC, 27215
(800) 334-5551

Connecticut Valley Biological
82 Valley Rd.
P.O. Box 326
Southampton, MA 01073
(413) 527-4030

Hole-in-Hand Butterfly Farm
147 W. Carlton Ave.
Hazleton, PA 18201
(717) 459-1327

Myers Butterfly Farm
Whitehouse Station, NJ 08889
(908) 534-5822

Nature Discoveries
389 Rock Beach Rd.
Rochester, NY 14617
(716) 544-8198